ARTIST'S PROJECTS YOU CAN PAINT

10 Floral Watercolors

by Kathy Dunham

international
artist

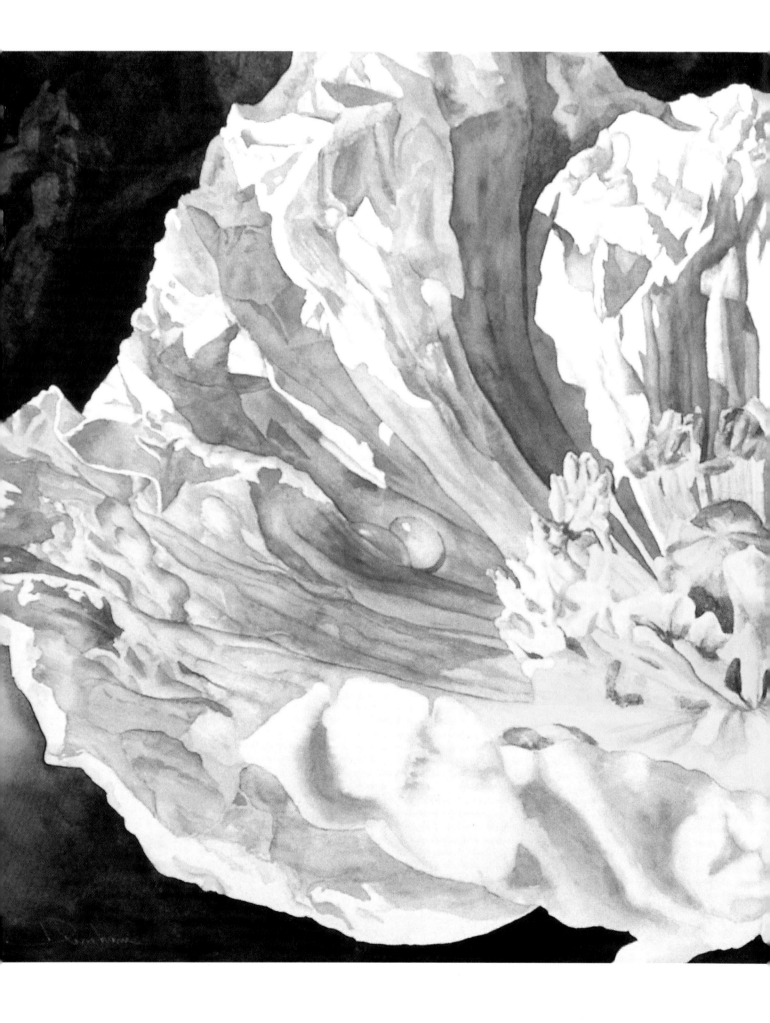

ARTIST'S PROJECTS YOU CAN PAINT

10 Floral Watercolors

by Kathy Dunham

international artist

International Artist Publishing, Inc
2775 Old Highway 40
P.O. Box 1450
Verdi, Nevada 89439

Website: www.internationalartist.com

Edited by Nicole Klungle and Terri Dodd
Designed by Vincent Miller
Typeset by Nicole Klungle, Nicolas Vitori
and Cara Herald

ISBN 1-929834-50-0

Printed in Hong Kong
First printed in hardcover 2004
08 07 06 05 04 6 5 4 3 2 1

Distributed to the trade and art markets
in North America by:
North Light Books,
an imprint of F&W Publications, Inc
4700 East Galbraith Road
Cincinnati, OH 45236
(800) 289-0963

Dedication

This book is dedicated to my mentor and friend,
Alan Lugena, who started me on the path
to the wonderful world of watercolor.

Acknowledgments

Thanks to all who encouraged me: students, friends and my wonderful
daughters Cindy and Karen and their families. To Terri Dodd, who
started me on this fascinating process, Vincent Miller for believing in
my abilities, Jennifer King for being there when I had questions and,
most of all, Nicole Klungle for making sure I crossed all the t's and
dotted those i's. Couldn't have done it without all of you.
Thanks!

*"When you take
a flower
in your hand
and really look at it,
it's your world
for the moment.
I want to
give that world
to someone else."*

— Georgia O'Keefe

Les Fleurs De Blanc

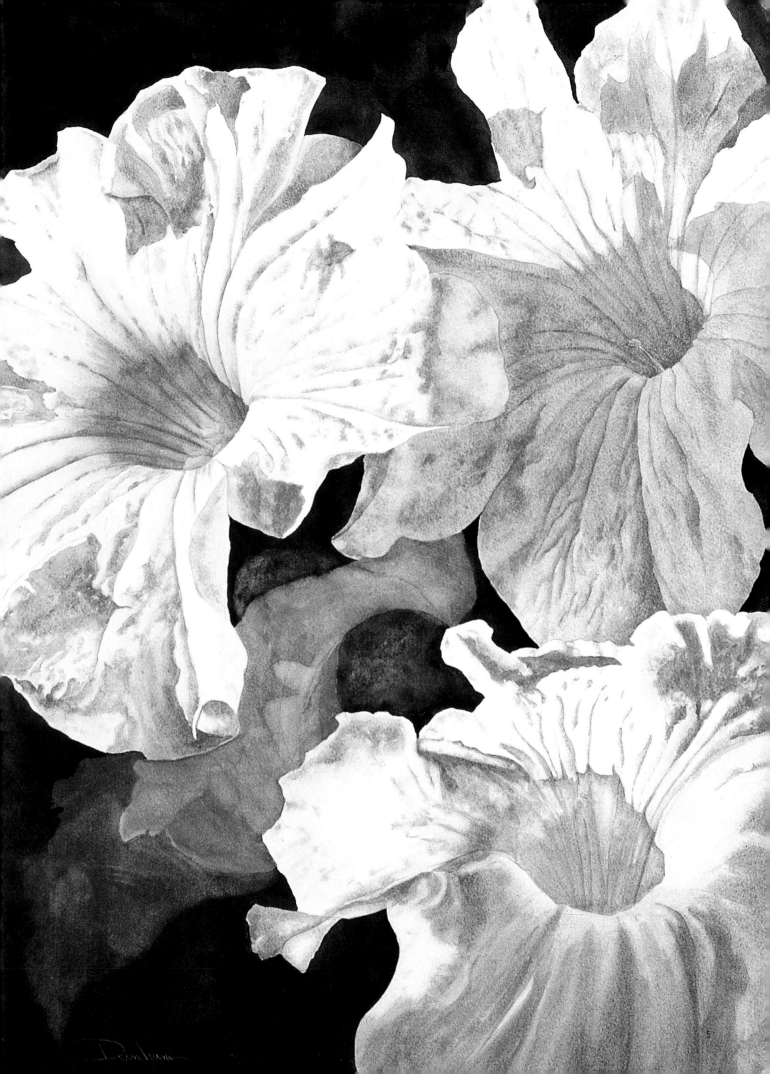

CONTENTS

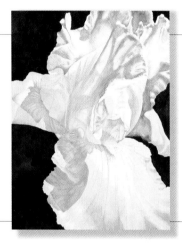
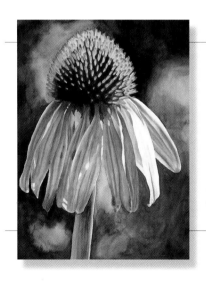
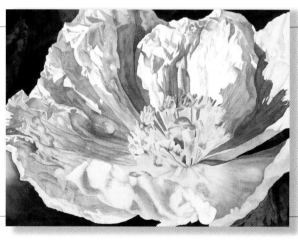
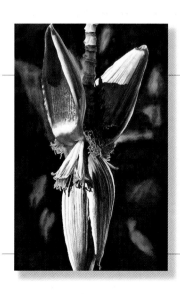

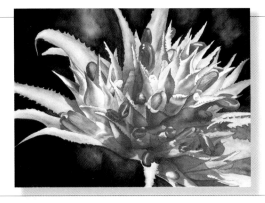

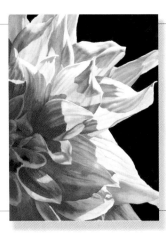

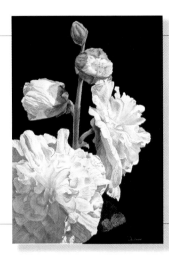

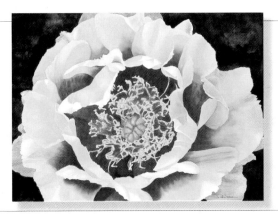

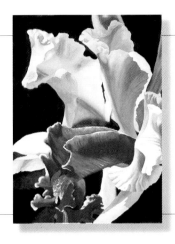

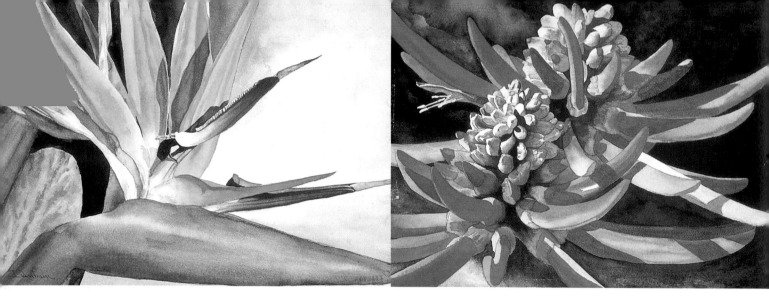

Bird of Paradise I

Red Hots

INTRODUCTION

Watercolor is the perfect medium for painting flowers because it allows you to recreate subtle transitions from one color to another, to capture the light as it shines through translucent petals, and to reproduce the gentle contours of the petals.

I choose my floral subjects for their drama. By using brilliant color and striking contrasts of values and color, I try to give the viewer a sense of being able to reach out and touch the flowers.

I am constantly seeking out flowers for my paintings. I keep my camera in the car so I'm always prepared to capture an unusual bloom or unique lighting. I want my paintings to represent flowers in nature, as they appear outdoors — not cut and arranged under artificial light. I love to paint natural sunlight falling across leaves and petals, creating shadow and light patterns so unique they are almost abstract.

I thank my mother for my love of flowers. The more I paint them, the more intimate I become with their intricacies. When you have a passion for a certain subject, study it. The greater your knowledge, the easier it is to convey your passion in your painting. Each flower species has its own special characteristics that become more obvious as I paint them. When I am curious about a plant or flower I have not painted before, I pull out my botanical books and start researching. You can never have too much knowledge of your subject. If it weren't for the passion I have for flowers, I don't think I would be able to capture their beauty in my paintings.

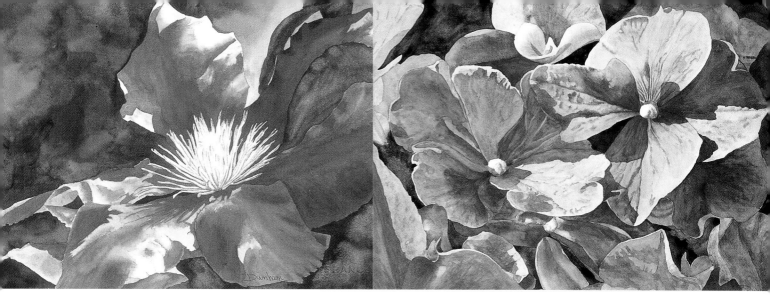

Purple Clematis

Purple Hydrangea

How to use this book

There is no magic formula that guarantees a successful painting. Experience, knowledge and intuition all play a key role in producing a finished paint that makes the viewer say "Wow!" The projects in this book are designed to assist you in achieving that Wow! factor. Each project is broken down into five or six general steps. Of course, it is by no means possible to detail every brushstroke in a few steps, so consider the steps as general guidelines to the painting process. Within these steps, I've tried to elaborate on the concepts, painting techniques and design strategies that make each painting visually intriguing. Extract the lessons from each chapter and incorporate them into your individual painting style. In time, and with continued practice, you too will become an accomplished watercolorist.

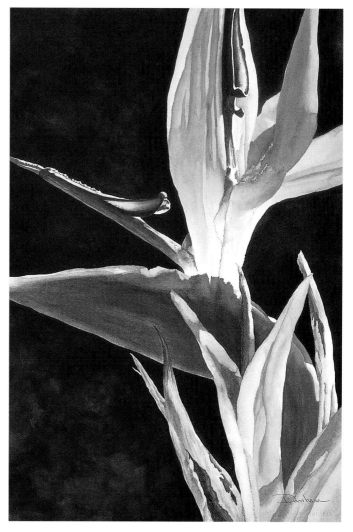

Bird of Paradise II

Materials you will need to paint every project in this book

It is important to use artist-grade materials if you want to achieve optimum results. You may save a few dollars at first by using student-grade supplies, but your painting will suffer. The colors will be weaker and duller, and you won't be able to control them as well. Paint won't lift or flow as well on poor-quality paper, and cheap brushes will shed bristles while making it difficult to manipulate your paint.

I have given the generic pigment names for the paints I use. You should be able to find the same colors in many top-quality paint brands.

My brushes are sable rounds or squirrel-hair mops. Squirrel-hair brushes hold a tremendous amount of paint, allowing me to cover large areas without returning to my palette for more pigment. This is particularly useful when you don't want the paint on the paper to dry before you can add more. Squirrel-hair brushes can also

hold an extremely fine point for painting details, eliminating the need for small brushes that don't hold much pigment.

You can get good synthetic brushes if you prefer not to use animal hair.

Get to know your paints. Know the difference between staining and nonstaining pigments and how they affect your ability to lift color off the paper. I often use granulating colors when I want extra texture without the work. Evaluate your pigments for color temperature and bias (see Project 8 on page 70 for more information) and experiment with mixing them.

When you reach a high level of comfort and familiarity with artist-grade materials, you will be able to focus all your energy on creating a beautiful painting rather than on the mechanics of manipulating paint on paper.

Brushes
Round and mop brushes 2, 4, 7 (sable, squirrel hair or synthetic)
2" wash brush
Stiff bristle scrubber

Paper
140lb (300 gsm) cold-pressed watercolor paper

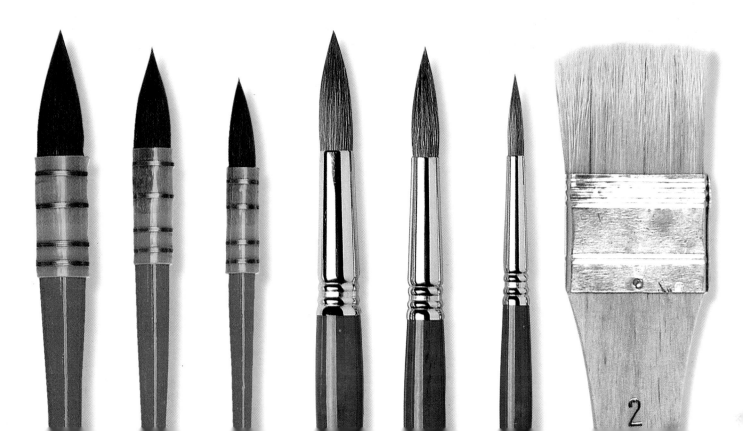

20 Artist quality watercolors

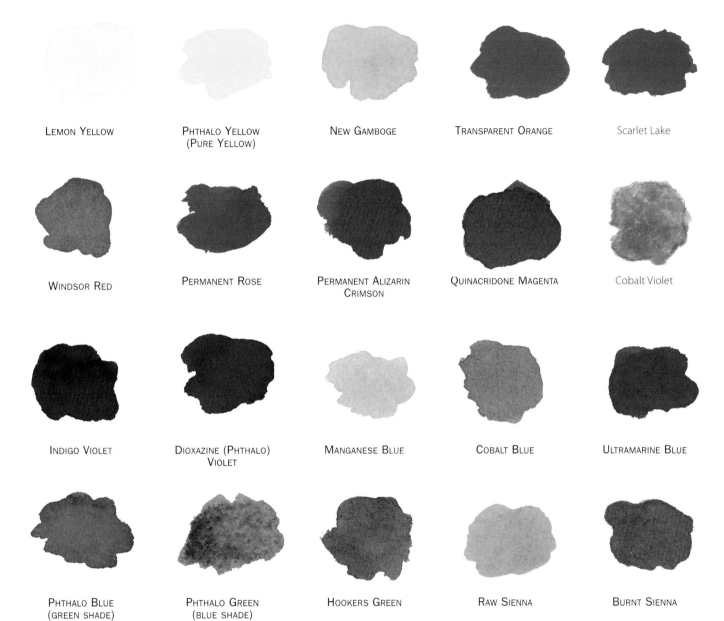

LEMON YELLOW	PHTHALO YELLOW (PURE YELLOW)	NEW GAMBOGE	TRANSPARENT ORANGE	Scarlet Lake
WINDSOR RED	PERMANENT ROSE	PERMANENT ALIZARIN CRIMSON	QUINACRIDONE MAGENTA	Cobalt Violet
INDIGO VIOLET	DIOXAZINE (PHTHALO) VIOLET	MANGANESE BLUE	COBALT BLUE	ULTRAMARINE BLUE
PHTHALO BLUE (GREEN SHADE)	PHTHALO GREEN (BLUE SHADE)	HOOKERS GREEN	RAW SIENNA	BURNT SIENNA

Other Materials

Hairdryer

Pencils

Tracing paper

Masking fluid

Use the color mix swatches as your guide

You'll find lots of example color mixes as you work
through the projects.

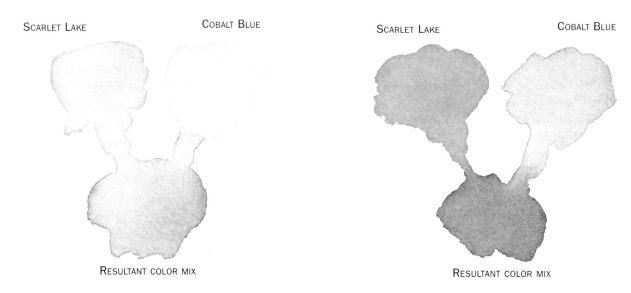

SCARLET LAKE COBALT BLUE SCARLET LAKE COBALT BLUE

RESULTANT COLOR MIX RESULTANT COLOR MIX

Notice that the same colors were mixed together in these swatches, but depending on the
intensity of the paint and the amount of water used you get slightly different shades.

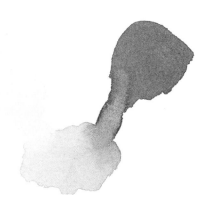

You can get a vibrant, fresh green mixing Lemon Yellow with Cobalt Blue.

For delicate shades you can start with Phthalo Yellow and add more Dioxazine Purple.

Other useful colours are:

LEMON YELLOW RAW SIENNA

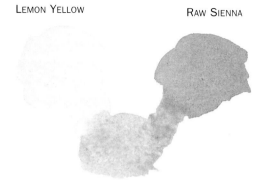

RAW SIENNA BURNT SIENNA COBALT BLUE

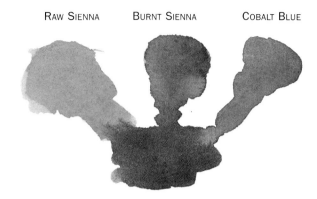

Glazing methods and effects

Glazing is a very useful technique. It allows you to layer one color over another to enhance depth of color, change a color, create a new color or correct a color.

Glazing is often the best way to obtain an unusual color. Instead of mixing the wet pigments together on your palette and risk creating mud, you layer the colors separately on your paper.

No two glazed areas will have exactly the same color mix or value.

Layering creates natural variation and interest in your painting by allowing all the different colors and values to show through, particularly in the lighter values.

The key to successful layering is letting each layer dry before applying the next. Apply each layer in one stroke so as not to disturb the pigment in the bottom layers.

PETAL MIX

2 LAYERS OF PETAL MIX

3 LAYERS OF PETAL MIX

4 LAYERS OF PETAL MIX

5 LAYERS OF PETAL MIX

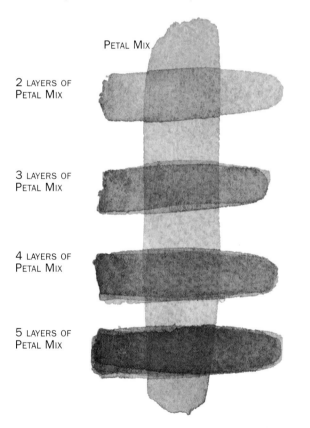

PETAL MIX

MANGANESE BLUE

RAW SIENNA

COBALT VIOLET

BURNT SIENNA

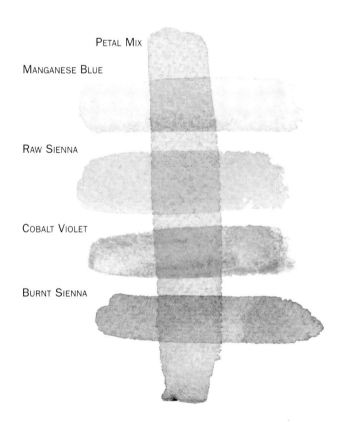

Copyright warning!

PROJECT 1 GOOD MORNING SUNSHINE

How contrast gets instant impact

Planning your painting is the most important thing you can do to ensure success. Well-designed paintings have a clear center of interest, a strong eye-path and good tonal balance. All these elements work together — the values of your subject help create a path for the viewer's eye to follow through the painting to the center of interest. Before you begin the project, please take a few minutes to read it through so you know the sequence you will be following.

The challenges
- To decide on your center of interest.
- To envision an eye-path.
- To plan your value scheme.
- To focus on good design rather than becoming absorbed in the painting process.

What you'll learn
- This project will teach you to create a center of interest using contrast.
- You will create supporting elements, but you'll learn how to subordinate these to your center of interest.

The techniques you'll use
- large washes
- wet-into-wet
- masking
- glazes
- wet-onto-dry

Design your center of interest
The first step in creating a good design is selecting a center of interest, or focal point. This is where you want to hold the viewer's eye. It's the star of the show. All other elements of the painting are supporting cast members.

The center of interest can be an unusual petal or color combination, the center of the flower, or where the greatest contrast occurs. To direct the viewer's eye to the center of interest, create an eye-path and design your focal point with the most detail and the highest value contrast.

Create an eye-path with shape
An eye-path is a tool to link all the supporting members of your cast to the star of the painting: the center of interest. The path can be shadows, leaves, stems and/or petals — all subtly pointing where you want the viewer to look.

I always try to make an eye-path in my paintings, even if the subject is a single flower. Eye-paths can take many shapes: the circle pattern is one of the most common. There is also the S-shape, the cross-shape, the L-shape and the triangle, but I prefer the circle because it keeps the viewer's eye in the painting the longest.

Create value contrast
Once you have laid out your basic drawing, it's time to decide on your value patterns. Values are the lights and darks in your painting. A sharp contrast between a light value and a dark one is interesting to the eye. To create the greatest impact, it's important to have the strongest value contrasts at or near your center of interest.

NEW GAMBOGE (YELLOW)

TRANSPARENT ORANGE

PERMANENT ALIZARIN CRIMSON (RED)

HOOKERS GREEN

DIOXAZINE (PHTHALO) VIOLET

ULTRAMARINE BLUE

Create color contrast
Any form of contrast attracts the eye, and that includes color contrast. Complementary color schemes, in which two colors from opposite sides of the color wheel are used together, create interest. The orange poppy rests against a dark background of its color complement, blue.

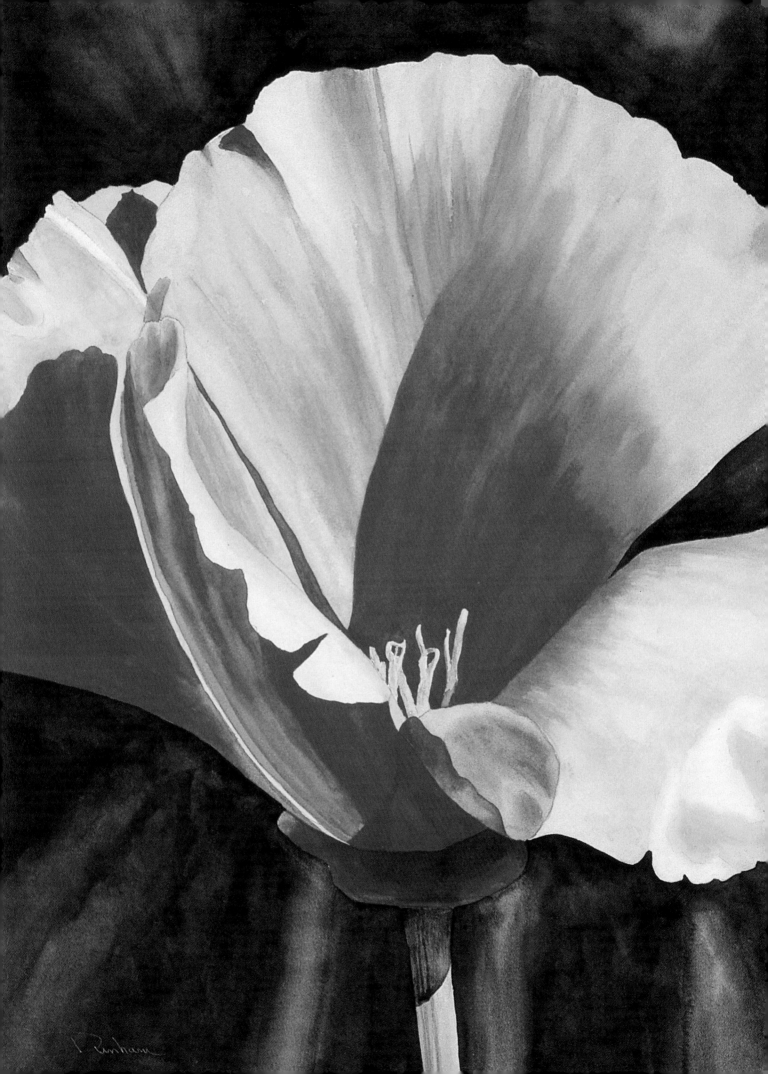

The materials you'll need for this project

Paper (Support)

I recommend 140lb (300gsm) cold-pressed artist-quality watercolor paper. Work at a small size to begin with. As your confidence grows, you can graduate to the 30 x 22" size I often use.

Pencils and tracing paper

Use a no. 2 pencil to trace and transfer your design onto watercolor paper. You can also use graphite paper to transfer the drawing. See Step 1 for more information.

Brushes

- no. 2 squirrel-hair
- no. 4 squirrel-hair
- no. 7 squirrel-hair

Masking fluid

If you don't feel confident about painting around the lightest areas, protect them with an application of masking fluid that can be rubbed off later.

Watercolors

Hairdryer

Use a hairdryer to speed up the drying process. At certain points, such as when applying glazes or painting details, it is essential that your paper is absolutely dry.

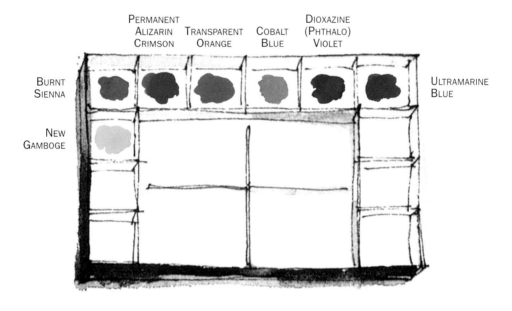

PERMANENT ALIZARIN CRIMSON · TRANSPARENT ORANGE · COBALT BLUE · DIOXAZINE (PHTHALO) VIOLET

BURNT SIENNA · ULTRAMARINE BLUE

NEW GAMBOGE

The center of interest

The circular eye-path

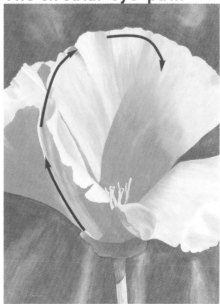

The value scheme

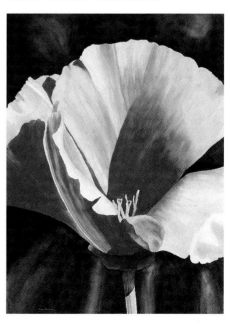

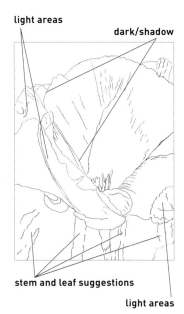

light areas

dark/shadow

stem and leaf suggestions

light areas

Regard your initial drawing as your map. If you study this drawing carefully and compare it with the finished painting, you will see that I have not only delineated the basic shapes, I have also noted some crucial shadows and passages of color and tone.

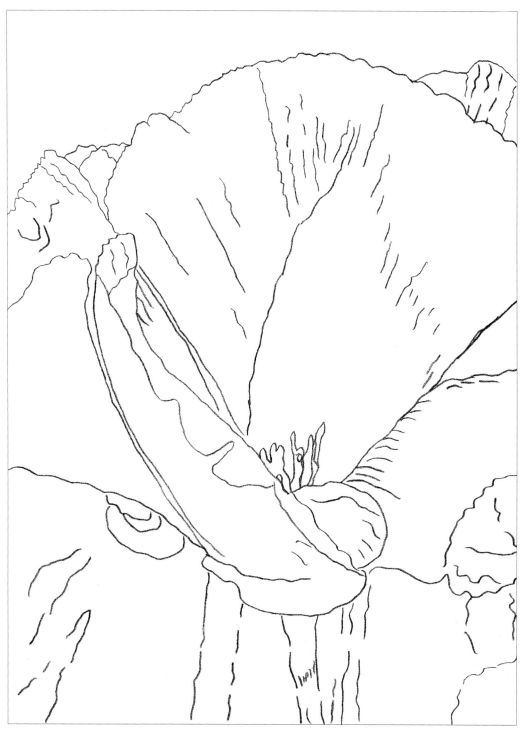

Step 1

Sketch, photocopy or trace this design onto your paper

In this stage, all we can see is a somewhat confusing, flat mass of line. It is our job to make this flat drawing look three-dimensional.

Sketch, trace or photocopy this drawing. (You can enlarge the drawing on a copy machine if you prefer to work on a larger image.) Transfer the design to your watercolor paper using graphite paper, or make your own transfer paper by covering the back of your tracing or photocopy with no. 2 pencil. While you are copying the design onto your watercolor paper, trace lightly so you don't ruin the surface of the paper.

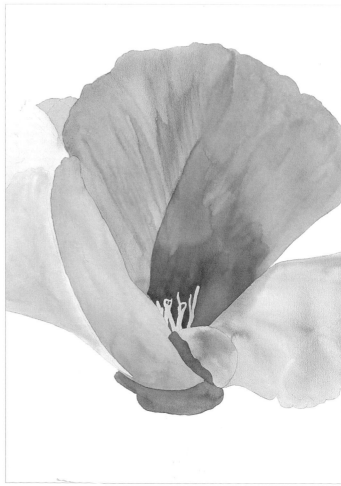

Step 2

Start with light washes

- You will be painting the washes wet-into-wet. This will help you avoid unwanted brushstrokes in case the paint dries too quickly. Cover the paper in a clear water wash first before adding color.

- With a mixture of New Gamboge and Transparent Orange, paint light washes over the entire flower, including the stamens.

- Once the wash is dry, you can apply masking fluid to the stamens before you apply the next, darker wash if you don't feel confident enough to paint around them.

Step 3

Lay in midvalues

- Add more pigment to darken your paint mix from Step 2 and lay in midvalue oranges. Where you need soft edges, paint wet-into-wet. For hard or sharp edges, paint wet-onto-dry.

- While your paper is still wet, add Permanent Alizarin Crimson to your mix to create an even deeper value. Drop this new color in, allowing the colors to subtly blend.

READ ME!

It takes a lot of water to do a successful wet–into–wet wash.

- First, mix plenty of color,
- Then evenly cover the area to be painted with lots of clear water.
- Next, wash on your color. Remember, the additional water on the paper will dilute your color. Make sure you use plenty of pigment.

TRANSPARENT ORANGE NEW GAMBOGE

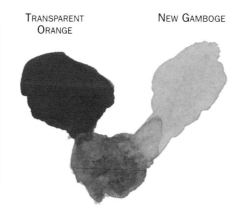

TRANSPARENT ORANGE PERMANENT ALIZARIN CRIMSON

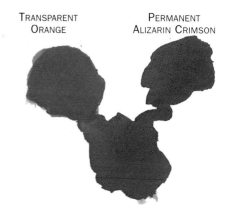

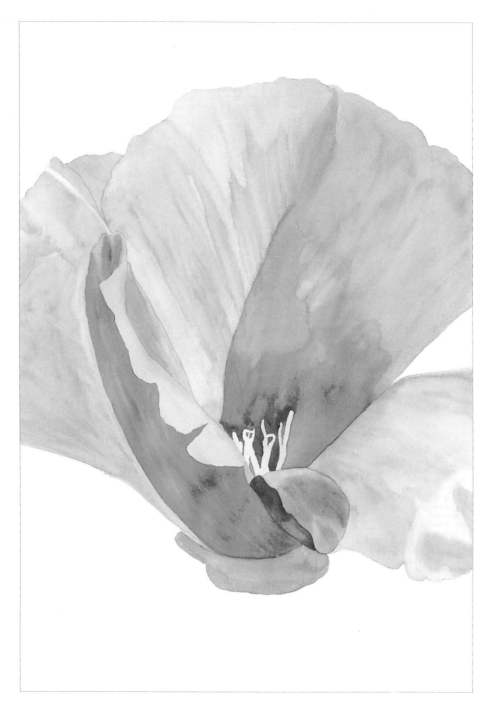

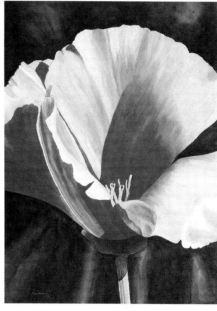

Planning values

The intensity of the orange on the petals makes it hard to notice that they are much lighter in value than the background. This black-and-white version of gives a clearer picture of the values. The darkest areas of the flower are the shadows under the left petal and in the center, behind the stamens. The shadows help balance the composition and set off the center of interest.

The center of interest

The stamens in this painting are the center of interest. Notice that they are more detailed than other areas of the painting — in fact, they are details themselves. This is also the area with the highest value contrast. The bright stamens really stand out against the deep orange throat of the flower.

READ ME!

Don't rush to get the color on the paper before you know it's right. If you're not sure you've mixed the correct color, dab a sample on scrap paper and let it dry before continuing. Remember, watercolor dries 15 to 20 percent lighter than it looks on your palette.

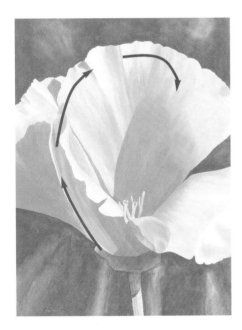

The eye-path

As you start to deepen the values in your painting, keep in mind you are also developing an eye-path for your viewer.

Even though you might plan the eye-path before you start painting, it can change as the painting evolves. In this painting, the viewer's eye may be initially attracted to the dark wedge on the right, or to the stem, which is a different color and value.

From the entry point at the bottom of the painting, the eye travels up to the flower and to the left, circling the outer edges of the petals. Then the eye follows the dark, diagonal shadow down to the stamens. Do you see it differently?

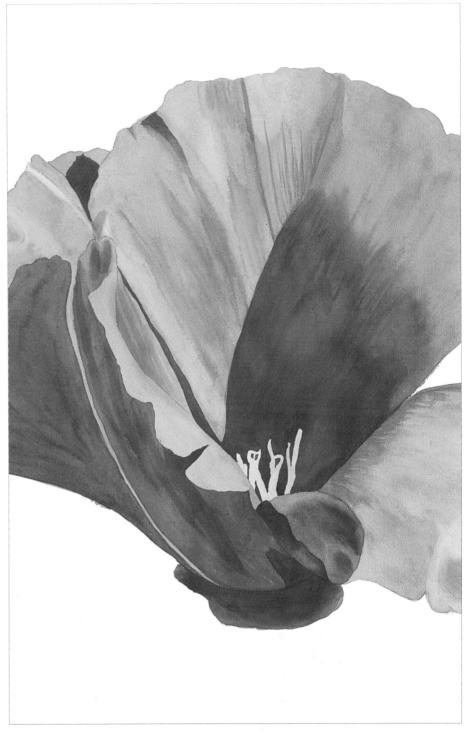

TRANSPARENT ORANGE BURNT SIENNA

Step 4

Paint the shadows

- Continue using the same mixture of Transparent Orange and Permanent Alizarin Crimson, but increase the ratio of pigment to water to darken the color. Notice that as the shadowed areas are deepened, the center of interest begins to stand out. The shadows curving into the area of interest form part of the eye-path, leading the eye to what you want it to see.

- Use a mix of Transparent Orange and Burnt Sienna for the darkest areas at the base of the flower.

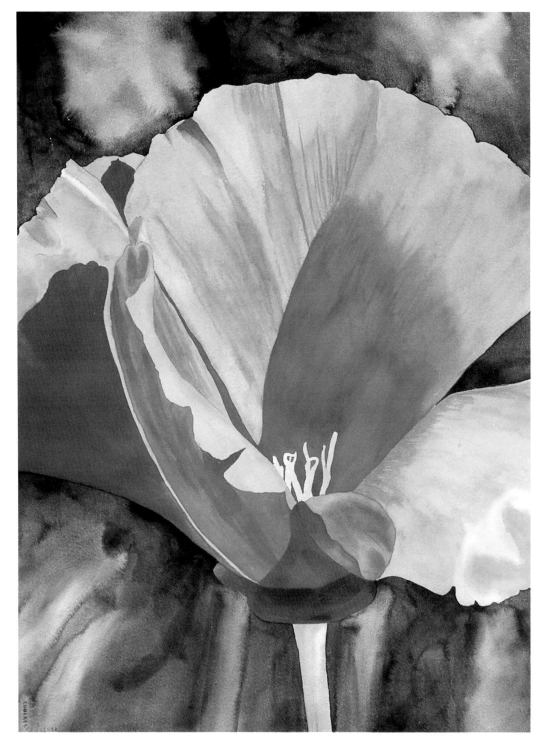

Step 6

Paint the background

- At the top of the painting, drop in mixtures of New Gamboge and Transparent Orange to suggest other poppies, again working wet-into-wet.

- Once your paper is dry, use an almost black mixture of Burnt Sienna, Ultramarine Blue and Dioxazine Violet to lay in an initial background wash. Dampen the areas around the background colors previously painted to create a soft edge.

- After the first background wash has dried, re-evaluate the values in the flower. If they're not dark enough, strengthen the color with washes of New Gamboge and Transparent Orange.

- You may also need to apply a second or third background wash to attain just the right dark value. Compare the picture on this page with the finished painting on page 15.

- When adding layers of paint to the background, apply clear water over the suggestions of stems and flowers. This allows the background color to mute, but not completely cover, the earlier passages.

Now turn to page 15 to see the finished painting.

CHECKPOINT

Compare your painting with the finished one. Notice any areas that you found difficult. Try this project as many times as you wish.

Step 5

Paint the stem

- Using a mixture of New Gamboge and Cobalt Blue, paint the stem of the flower. Add more blue to create the darks, including the cast shadow directly under the flower.

- Drop in varying shades of green on either side of the main stem. Paint them wet-into-wet to faintly indicate other stems.

COBALT BLUE NEW GAMBOGE DIOXAZINE (PHTHALO) VIOLET BURNT SIENNA ULTRAMARINE BLUE

PROJECT 2 LEMON MERINGUE

How to use hard and soft edges to suggest depth

Flowers offer a wondrous selection of shapes, patterns, colors and details. As an artist, it is your goal to suggest a three-dimensional flower on a two-dimensional surface. Conveying the intricate and delicate undulations of petals is a never-ending challenge. In this chapter, learn how to use hard and soft edges (also called lost and found edges) to create the illusion of depth in the folds and turns of petals and leaves.

The challenge

- To control your use of water to create hard and soft edges.

What you'll learn

- How the amount of water you use affects the spread of the pigment.
- Two techniques for creating soft edges.

The techniques you'll use

- wet-into-wet
- wet-onto-dry
- background washes

Hard edges

Hard edges are the crisp, sharp edges you see between clearly defined objects or between an object and the background. You can use hard edges to define petals or shadows. They help show detail and they separate the positive space in the painting (the flower) from the negative space (the background).

Soft edges

Soft edges are delicate, soft and feathery. They often look more like a transition or blend than an edge. You can use them to suggest contour, such as a subtle turn in a petal, to make an object appear soft in texture, and to indicate gradual changes in light and shape.

Hard edges

We will use a hard edge for the cast shadow and the edge of the petal where it meets the negative space of the background. The crisp edge of the shadow adds excitement to the painting by suggesting dramatic light.

Soft edges

The gradual transition of color from light to dark at the edge of the petal suggests shadows created by the flower's ruffled edge. To create this look, apply a darker color and soften the edges with water for a subtle blend. Some of the veining on the flower can be indicated using soft-edged color.

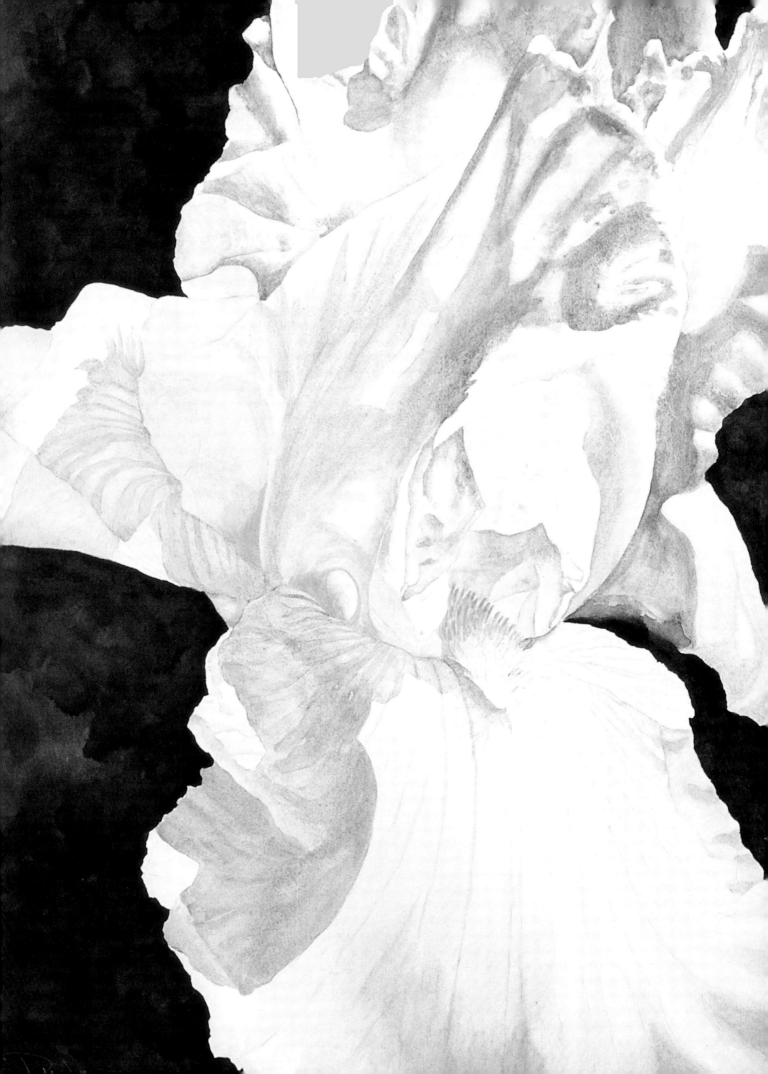

The materials you'll need for this project

Paper (Support)
I recommend 140lb (300gsm) cold-pressed artist-quality watercolor paper.

Pencils and tracing paper
Use a no. 2 pencil to trace and transfer your design onto watercolor paper. You can also use graphite paper to transfer the drawing. See Step 1 for more information.

Brushes
- no. 2 squirrel-hair
- no. 4 squirrel-hair
- no. 7 squirrel-hair

Hairdryer
Use a hairdryer to speed up the drying process. At certain points, such as when applying glazes or painting details, it is essential that your paper be absolutely dry.

Watercolors

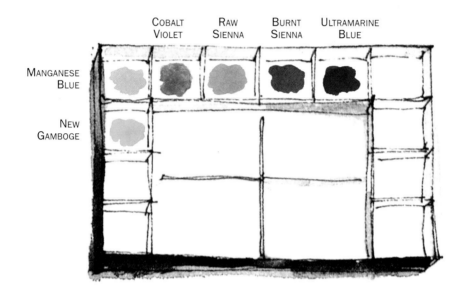

The center of interest

The eye-path

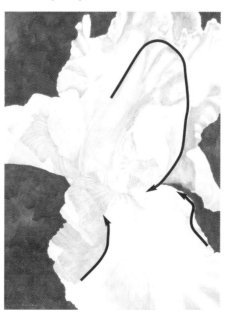

The value scheme

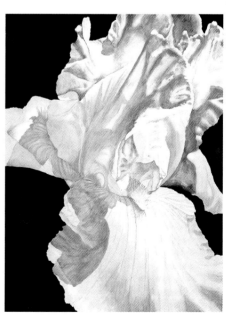

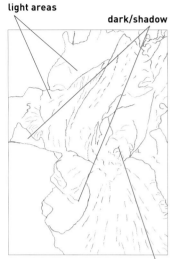

light areas

dark/shadow

light area

As before, regard your initial drawing as your map. If you study this drawing carefully and compare it with the finished painting, you will see that I have not just delineated the basic shapes, but also noted some crucial shadows and passages of color and tone.

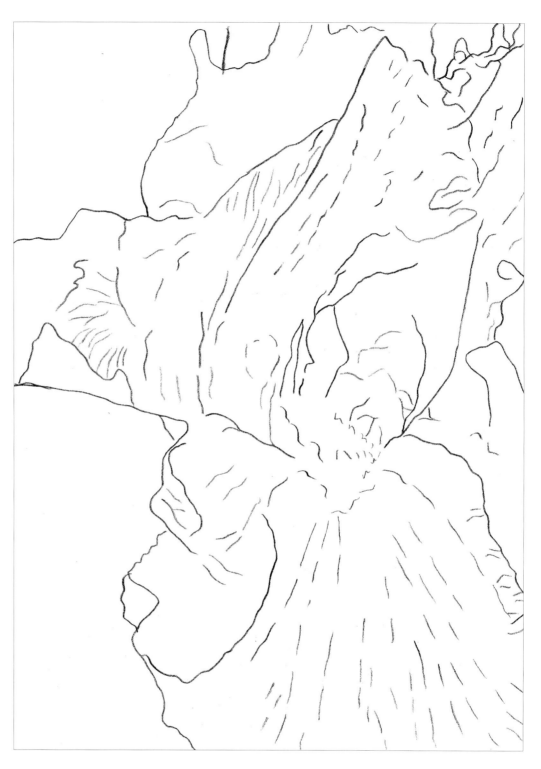

Step 1

Sketch, photocopy or trace this drawing

In this stage, all we can see is a somewhat confusing, flat mass of line. It is our job to make this flat drawing look three-dimensional.

Sketch, trace or photocopy this drawing. (You can enlarge this drawing on a photocopy machine if you prefer to work on a larger image.) Transfer the design to your watercolor paper using graphite paper, or make your own transfer paper by covering the back of your tracing or photocopy with no. 2 pencil. While you are actually copying the design onto your watercolor paper, trace lightly so you don't ruin the surface of the paper.

Step 2

Create washes of yellow with soft edges

- Working one section at a time, apply a wash of clear water to an area of a petal to be painted yellow. Make sure to cover an area larger than required. This additional wet area allows you more control.

- Now comes the tricky part. The wetter the area, the faster and farther the color will travel. Therefore, for optimum control, wait until the shine is gone but the paper is still damp before applying New Gamboge.

- As the color bleeds over the damp areas, it will create a soft edge. The eye translates this into the illusion of a turning petal. Continue this process for each area of yellow.

Alternate method

Another way to create soft edges is to apply the paint before the water. Then, while the paint is still wet, drag a damp brush along the edge you wish to soften.

Be careful! Too much water can ruin the effect.

READ ME!

Use two large containers of clean water for rinsing your brushes. Rinse your dirty brush in the first container, then rinse it again in the second to remove any remaining pigment. Change water frequently to maintain crisp, clean colors.

Step 3

Paint the veins with hard edges

- Paint the veins wet-onto-dry using New Gamboge. This will create hard edges.

- As the veins get farther from the center of the flower they should get softer and lighter. Soften the edges with a damp brush (see alternate method, above). Note: These veins must be painted before the shadows in the petals because they won't show up if painted over the shadow color.

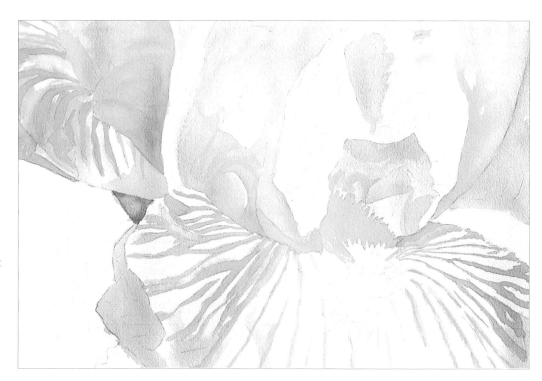

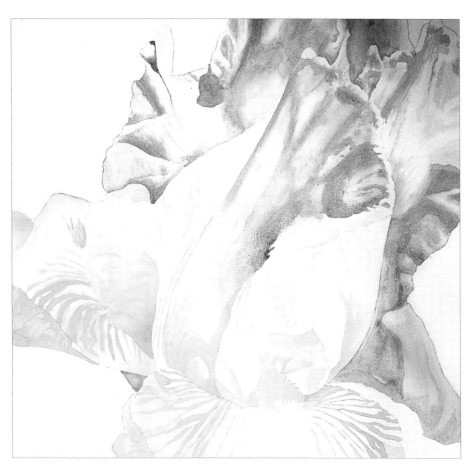

Step 4

Paint the shadows in the upper petals using both hard and soft edges

- Using a mixture of Manganese Blue, Cobalt Violet and Raw Sienna, paint the shadow areas in the white upper petals. Use the wet–into–wet technique to create soft edges where the petals turn and curl.

READ ME!

You can create more intense darks with layering than by applying one thick coat of paint.

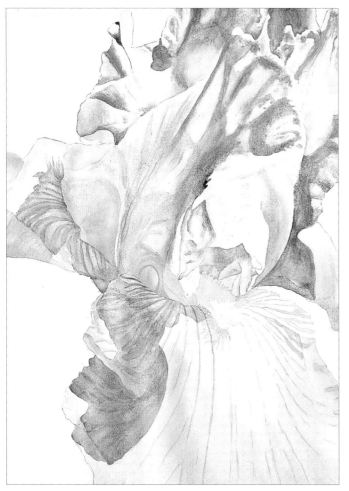

Step 5

Paint the shadows on the yellow petals

- Dilute the paint mix from Step 4 and apply it to the shadow areas in the yellow petals.

- Once the color has dried, you can add another layer to darken the shadows as needed.

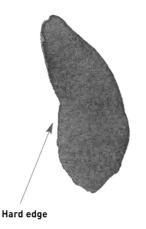

Hard edge

Soft edge

How to avoid blossoms and backruns

Blossoms and backruns are both caused by excess water in the area you are painting.

Blossoms tend to be circular and usually occur when you accidentally drop water or a wet mixture of paint on your paper. They can also be formed when you are adding paint to a damp area and there's more water in your brush than on the paper.

Backruns occur when excess water runs to the bottom of the paper, has nowhere to go, and starts running back into the painting. Avoid these frustrating and unattractive mishaps by carefully gauging just the right amount of water you need for your soft edges.

Blossom

Backrun

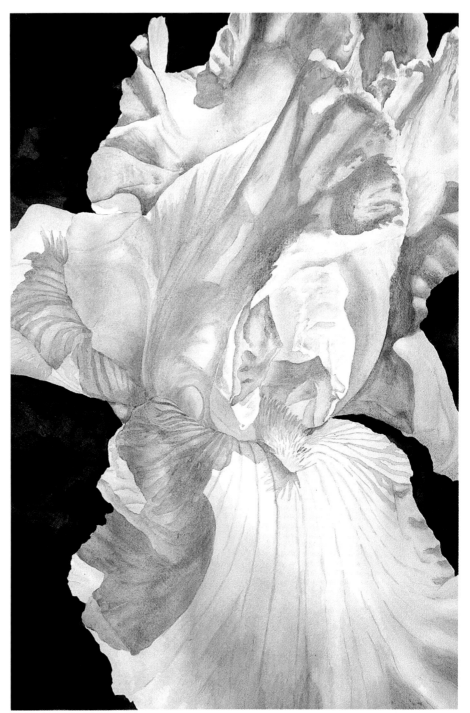

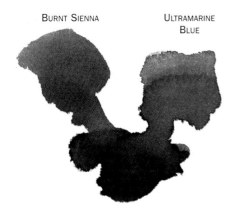

Burnt Sienna Ultramarine Blue

Step 6

Paint the background

Mix Burnt Sienna and Ultramarine Blue to create a deep, dark black. Apply two to three coats of this mixture for a background that will pop the flower right off the page.

CHECKPOINT

Compare your painting with this. Study your edges. Did you manage to achieve soft and hard edges? What did you find difficult? Try this project as many times as you wish.

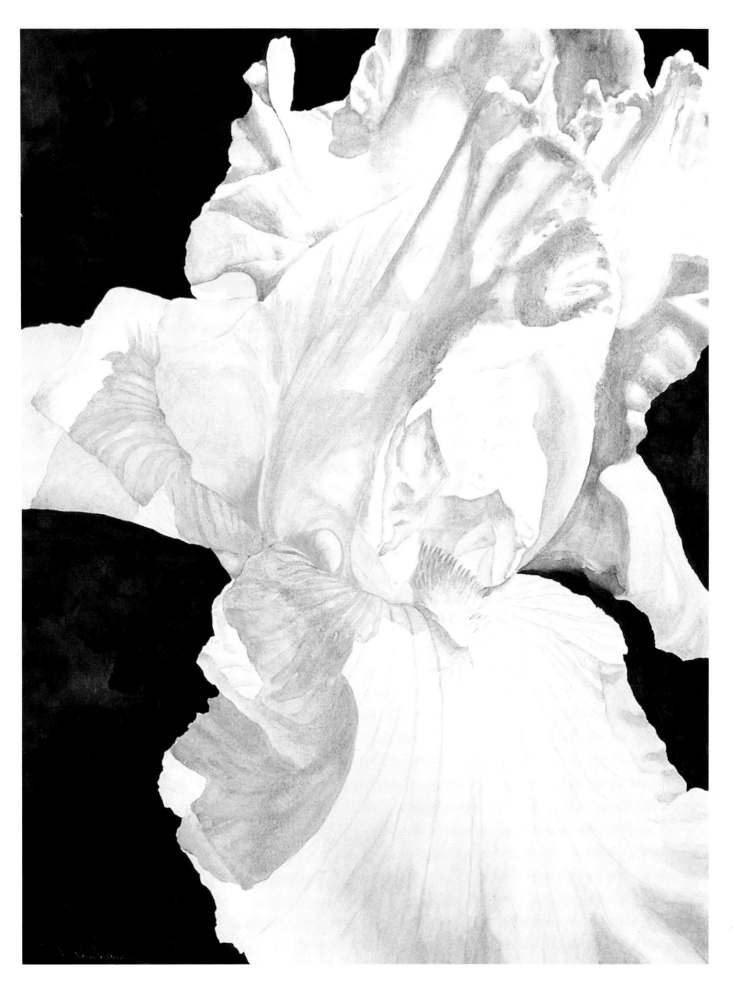

PROJECT 3 ECHINACEA

Build up lucious color with glazes

Glazing, also called layering, is one way to build beautiful depth of color in your paintings. Instead of applying the full value of a color in one brushstroke, you build up multiple layers of color to create an otherwise unattainable effect. Although glazing is possible in several painting media, watercolor is particularly suited to this process.
Please take the time to read this project through carefully, and do the exercises before you start.

The challenge
- To build depth through multiple layers of color.

What you'll learn
- To use successive layers of delicate washes to achieve a deep color.

The techniques you'll use
- large washes
- glazes
- wet-onto-dry
- wet-into-wet

How glazes deepen (darken) value

Make a beautiful petal mix from Manganese Blue, Cobalt Violet and Permanent Rose and apply a confident vertical stroke. Wait for the stroke to dry completely, then layer on successive glazes of the same mix. Wait for each glaze to dry completely before applying the next layer.

PETAL MIX

2 LAYERS OF PETAL MIX

3 LAYERS OF PETAL MIX

4 LAYERS OF PETAL MIX

5 LAYERS OF PETAL MIX

How glazes modify and enhance color

This time, lay down horizontal strokes of Manganese Blue, Raw Sienna, Cobalt Violet and Burnt Sienna. Wait for them to dry completely, then glaze a confident vertical stroke of petal mix on top. The underlying colors shine through the glaze, creating subtle, translucent effects.

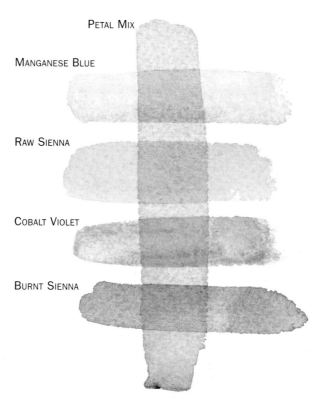

PETAL MIX

MANGANESE BLUE

RAW SIENNA

COBALT VIOLET

BURNT SIENNA

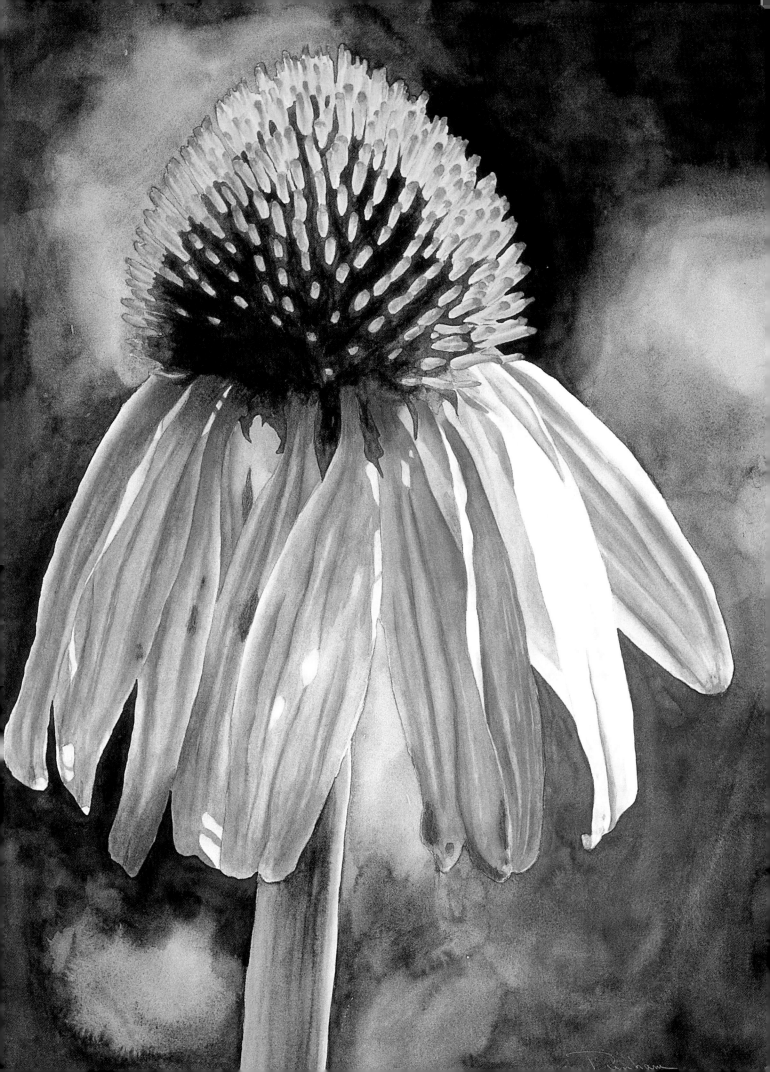

The materials you'll need for this project

Paper (Support)

I recommend 140lb (300gsm) cold-pressed artist-quality watercolor paper.

Pencils and tracing paper

Use a no. 2 pencil to trace and transfer your design onto watercolor paper. You can also use graphite paper to transfer the drawing. See Step 1 for more information.

Brushes

- no. 2 squirrel-hair
- no. 4 squirrel-hair
- no. 7 squirrel-hair
- no. 6 sable

Masking fluid

If you don't feel confident enough to paint around the lightest areas, protect them with an application of masking fluid.

Hairdryer

Use a hairdryer to speed up the drying process. At certain points, such as when applying glazes or painting details, it is essential that your paper is absolutely dry.

Watercolors

MANGANESE BLUE NEW GAMBOGE BURNT SIENNA RAW SIENNA

COBALT VIOLET HOOKERS GREEN

PERMANENT ROSE ULTRAMARINE BLUE

PURE YELLOW (PHTHALO YELLOW) DIOXAZINE (PHTHALO) VIOLET

The center of interest

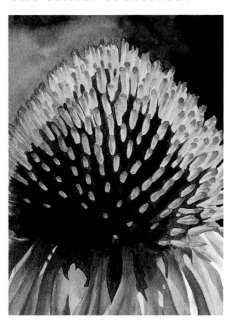

The eye-path

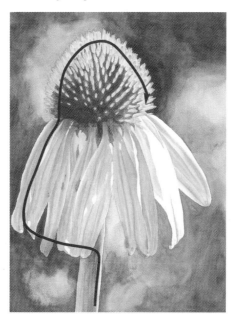

The value scheme

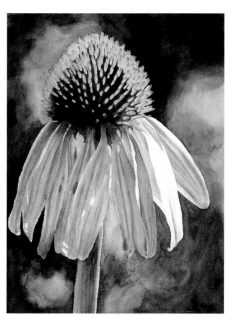

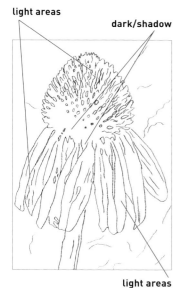

light areas

dark/shadow

light areas

Regard your initial drawing as your map. If you study this drawing carefully and compare it with the finished painting, you will see that I have not just delineated the basic shapes, but also noted some crucial shadows and passages of color and tone.

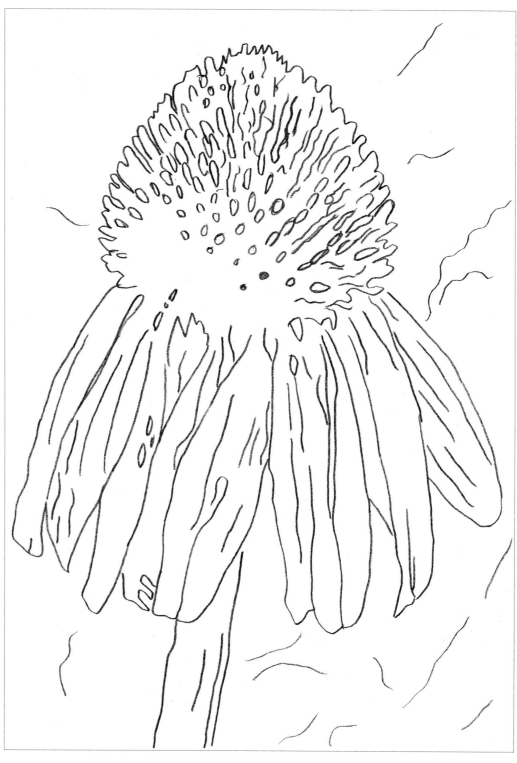

Step 1

Sketch, photocopy or trace this drawing

In this stage, all we can see is a somewhat confusing, flat mass of line. It is our job to make this flat drawing look three-dimensional.

Trace or photocopy this drawing. (You can enlarge the drawing on a copy machine if you prefer to work on a larger image.) Transfer the design to your watercolor paper using graphite paper, or make your own transfer paper by covering the back of your tracing or photocopy with no. 2 pencil. While you are actually copying the design onto your watercolor paper, trace lightly so you don't ruin the surface of the paper.

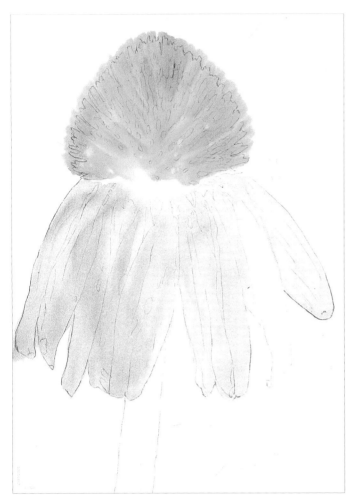

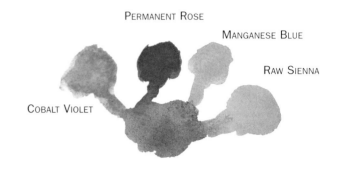

PERMANENT ROSE

MANGANESE BLUE

RAW SIENNA

COBALT VIOLET

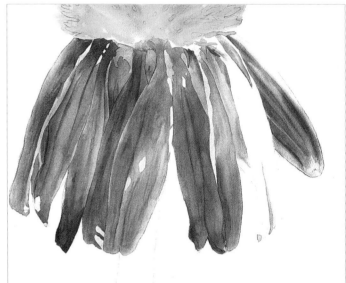

Step 2

Apply the first washes

- Make petal mix using Permanent Rose and Cobalt Violet. Apply a light wash to the petals. Mask out the single white petal or simply paint around it. For the cone-shaped center, first apply a wash of New Gamboge. While this is still damp, drop in Burnt Sienna and let the colors bleed to give the entire head a mottled look.

PERMANENT ROSE COBALT VIOLET

READ ME!

When layering with non-staining colors, use an extremely soft bristle brush or you will lift previous layers. In addition, make sure to use a single stroke to apply paint. Moving the brush back and forth will also loosen earlier layers.

Step 3

Paint the petals

- To achieve the illusion of sunlight shining through the petals, when the petals are dry give them a light wash of Raw Sienna. Once this wash is dry, paint the dark ribs on each petal with a mix of Permanent Rose, Cobalt Violet and Manganese Blue. For the spots and brown tips, mix Burnt Sienna with a touch of Hookers Green. It makes a wonderful dirty brown.

- Mix Permanent Rose and Cobalt Violet, then add a touch each of Manganese Blue and Raw Sienna to create a drab mauve. Working wet-into-wet, paint all the petals except the one on the right in direct sunlight. Leave that one white. Paint around the light spots on the petals. These can always be darkened later if needed. To get the extra dark veins, combine Raw Sienna with Manganese Blue and add while the petal is still damp.

BURNT SIENNA HOOKERS GREEN

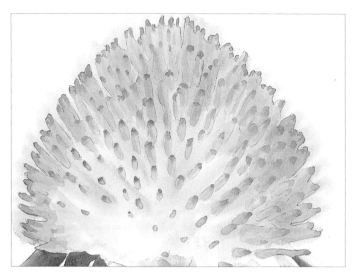

Step 4

Develop the stamens

- Apply New Gamboge to the yellow stamens. When they are dry, put touches of Burnt Sienna on the tips and soften with clear water.

Step 5

Add the darks

- For the dark center, combine Burnt Sienna and Hookers Green to create a deep greenish brown. Carefully paint around the stamens. Since this is just the first layer of the dark center, don't worry about brushstrokes or blossoms because you will be applying another layer of dark that will cover these.

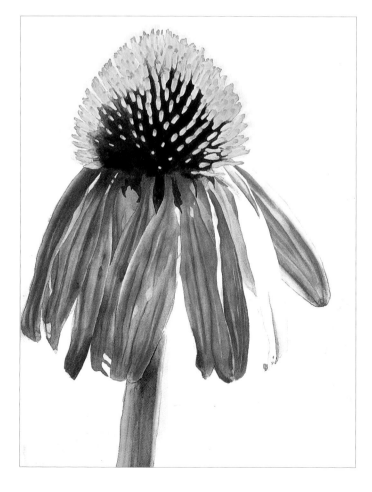

NEW GAMBOGE BURNT SIENNA BURNT SIENNA HOOKERS GREEN

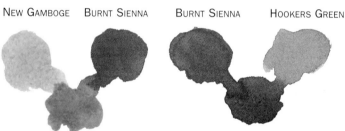

Step 6

Intensify with glazes

- As you go, keep applying glazes of the mauve mixture, darkening the petals.

- For the second layer of the brown center, add Ultramarine Blue to the Burnt Sienna and Hookers Green mix to intensify it. Soften the edges at the base of the center and drag some of the dark pigment over the top of the petals, blending into the mauve.

- Once this second layer of the dark brown dries, re-evaluate the yellow stamens. Add a richer combination of New Gamboge and Burnt Sienna to shift the stamens more toward orange than yellow.

- Paint the stem wet-into-wet. First, with a combination of Hookers Green and Pure Yellow, paint the right side of the stem where the light is hitting it. Next, just before this dries, darken the green with Ultramarine Blue and apply to the rest of the stem, putting the darkest stroke on the middle right of the stem for the deepest part of the shadow.

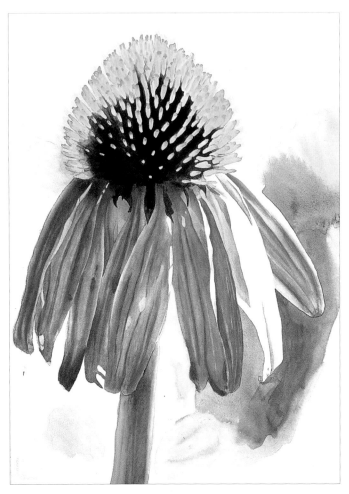

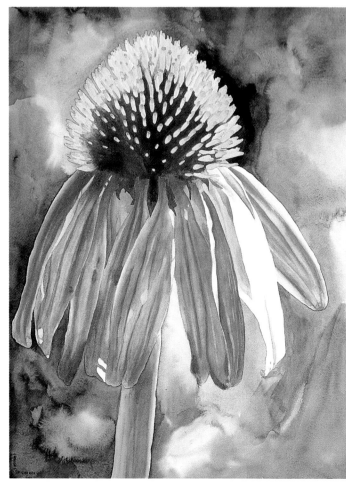

Step 7

Paint the background

We're going to introduce a lot of activity into the background of this painting. To suggest there are more flowers, apply random light washes of the mauve mixture (Permanent Rose, Cobalt Violet and Manganese Blue) wet-into-wet to spots in the upper parts of the background. You can also apply spots of yellows and light greens to hint at other flowers.

Step 8

Now the second layer

- For the second layer of the background, mix Hookers Green with Dioxazine Violet and touches of Ultramarine Blue. Change the mix ratio constantly to avoid painting a boring and flat background. To help preserve the integrity of some of the lighter patches, cover them with clear water before you start painting. Make a strong mix of Hookers Green and Dioxazine Violet for the darkest areas.

- Step back and evaluate the background. If you feel the light areas are too light, subdue them with a pale wash of Ultramarine Blue. Your greens may still be too bright. If so, paint over them with a glaze of Dioxazine Violet.

Step 9

Use a glaze to modify a color

Add a third layer of color to the stamens to make them more orange. This color will work better with the background. A perfect example of how layering works.

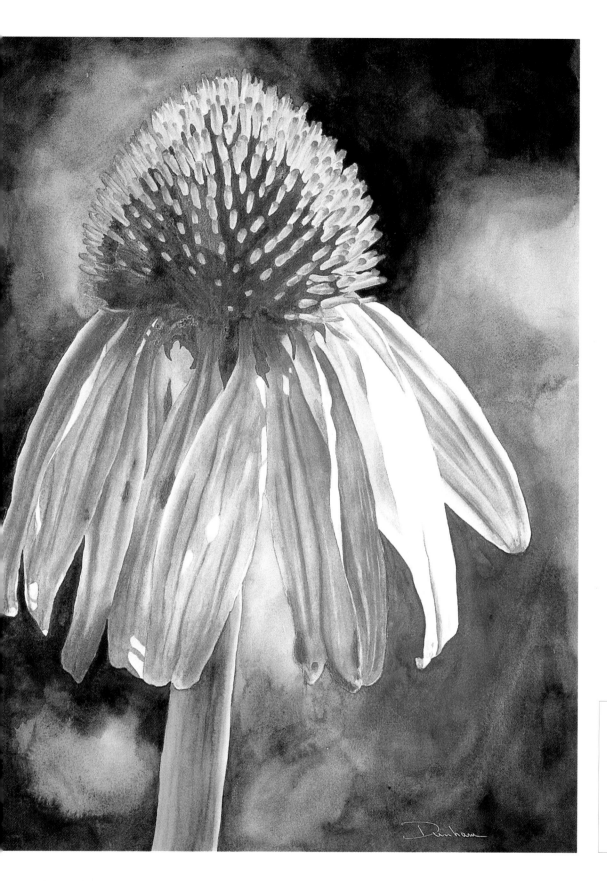

READ ME!

Always make your brushstroke in the direction of the predominant shape or line. Doing this will help define the shape.

CHECKPOINT

Compare your finished painting with my version. What do you notice? Can you see how valuable glazes are? Now you can use the technique in all your work!

PROJECT 4 PEACHES 'N CREAM

Dramatize the light with shadows

The most important reason to include knockout shadows in your painting is the life they add. You can't have dynamic highlights without equally dynamic darks. Your flower can't shine without shadows.

Please take the time to read this project through before you start painting, so you know the sequence.

The challenge

- To paint the palest of washes.
- To create depth and drama with shadows.

What you'll learn

- How to create delicate tints.
- How to paint water droplets.

Techniques we'll use

- large washes
- glazes
- wet-onto-dry
- wet-into-wet
- masking

How dark does a shadow have to be?

The required darkness of a shadow depends on the overall value of the flower. As a rule of thumb, make your shadows three to five values darker than your light areas. Therefore, the shadows in pale flowers can be lighter than those in dark flowers while still indicating depth and perspective.

Delicate tints

When you paint pale flowers always begin with very light washes. Such delicate tints require a lot of water, and it may seem at first that you're adding too much. Stick with it and you'll see how beautiful a color can become when diluted.

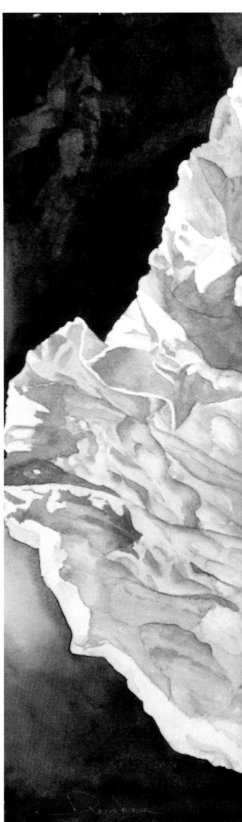

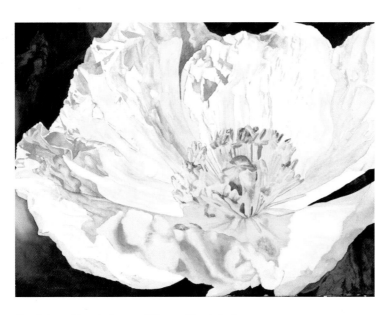

Here's how this painting would look without shadows

The deep shadows in the flower petals have been lightened in the image above, making the flower much less dramatic. When painting flowers, never be afraid of the darks.

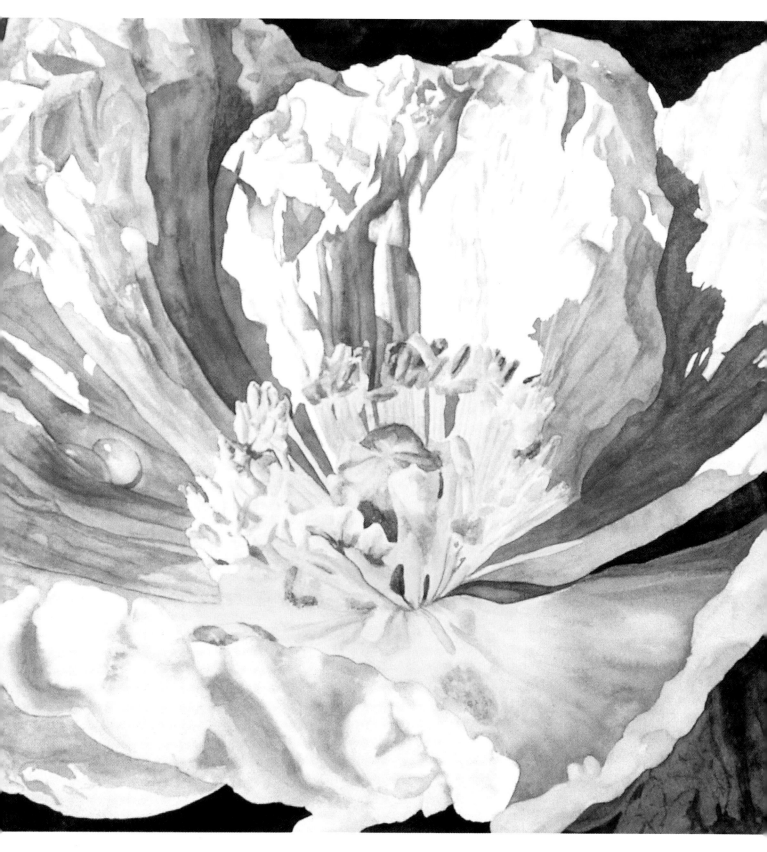

The materials you'll need for this project

Paper (Support)
I recommend 140lb (300gsm) cold-pressed artist-quality watercolor paper.

Pencils and tracing paper
Use a no. 2 pencil to trace and transfer your design onto watercolor paper. You can also use graphite paper to transfer the drawing. See Step 1 for more information.

Brushes
- no. 2 squirrel-hair
- no. 4 squirrel-hair
- no. 7 squirrel-hair
- no. 8 sable

Masking fluid
If you don't feel confident about painting around the lightest areas, protect them with an application of masking fluid.

Hairdryer
Use a hairdryer to speed up the drying process. At certain points, such as when applying glazes or painting details, it is essential that your paper is absolutely dry.

Watercolors

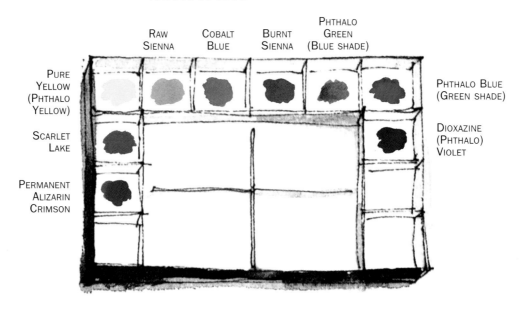

RAW SIENNA · COBALT BLUE · BURNT SIENNA · PHTHALO GREEN (BLUE SHADE)

PURE YELLOW (PHTHALO YELLOW)

SCARLET LAKE

PERMANENT ALIZARIN CRIMSON

PHTHALO BLUE (GREEN SHADE)

DIOXAZINE (PHTHALO) VIOLET

The center of interest

The eye-path

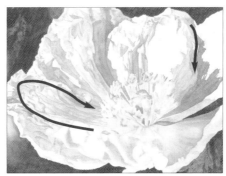

The value scheme

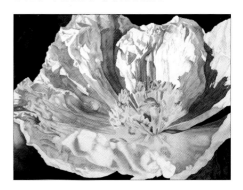

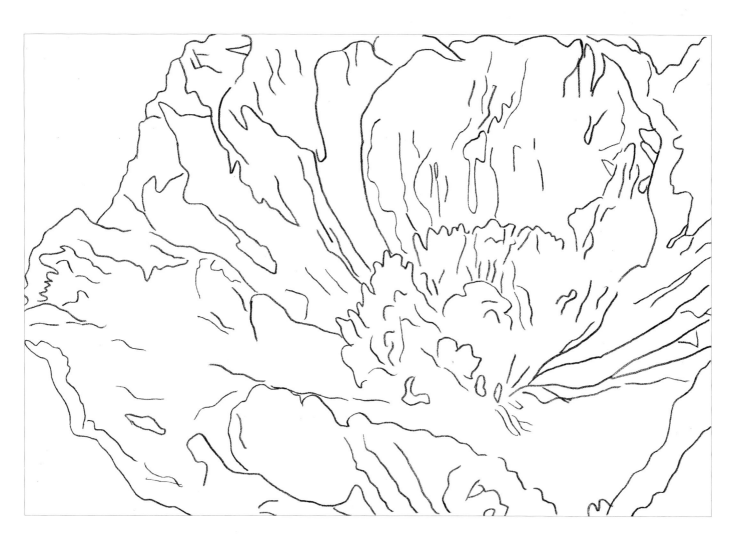

Step 1

Sketch, photocopy or trace this drawing

In this stage, all we can see is a somewhat confusing, flat mass of line. It is our job to make this flat drawing look three-dimensional.

 Trace or photocopy this drawing. (You can enlarge the drawing on a photocopy machine if you prefer to work on a larger image.) Transfer the design to your watercolor paper using graphite paper, or make your own transfer paper by covering the back of your tracing or photocopy with no. 2 pencil. While you are actually copying the design onto your watercolor paper, trace lightly so you don't ruin the surface of the paper.

light areas dark/shadow

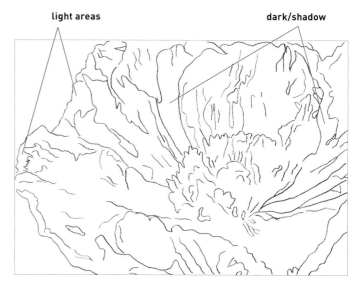

Regard your initial drawing as your map. If you study this drawing carefully and compare it with the finished painting, you will see that I have not just delineated the basic shapes, but also noted some crucial shadows and passages of color and tone.

Step 2

Lay in pale washes of color

READ ME!

Washes require large amounts of water. Avoid accidental hard edges — mix more than you think you need so you won't run out before you finish the wash.

- Starting with the yellow stamens, lay in light washes of Pure Yellow.

- Then mix a pale green with Cobalt Blue and Pure Yellow. Apply this to the center while the initial wash is still damp.

- As the wash dries, add a mix of Raw Sienna, Burnt Sienna and Cobalt Blue to define the darks in the stamens and help you see the value patterns. Trail a wet brush over some of the edges to soften them and give the shading a more natural look.

Step 3

Apply diluted color to the petals

- Once the yellow wash is DRY dried, start applying pale washes of Scarlet Lake to the petals. In its pure form, Scarlet Lake is a vibrant red orange. Heavily diluted, it becomes a delicate peach.

- Remember to save the white of the paper where the sun is hitting the petals. The contrasts of these whites make the shadows look even darker.

| HEAVILY DILUTED SCARLET LAKE | COBALT BLUE | PURE YELLOW (PHTHALO) | COBALT BLUE BURNT SIENNA RAW SIENNA |

Step 4

Here come those important shadows!

READ ME!

Always remember to keep the direction of your shadows the same.

SCARLET LAKE COBALT BLUE

- Use a mixture of Scarlet Lake and Cobalt Blue to apply key shadows. These will give depth to the flower. This step also helps set value patterns. This particular flower has a lot of ridges, which cause a wonderful array of shadows, defining the uniqueness of each petal.

- Slowly paint the lighter shadows using only Scarlet Lake. As the shadows get darker, add small amounts of Cobalt Blue. Don't let the mix turn to purple. The shadows in the "crinkles" are mainly deeper values of Scarlet Lake with a touch of Cobalt Blue in the darkest areas.

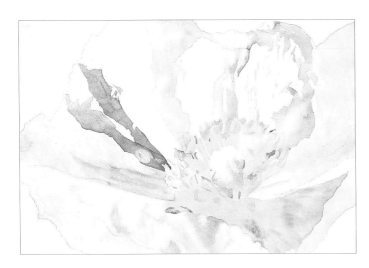

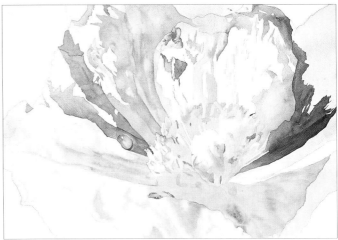

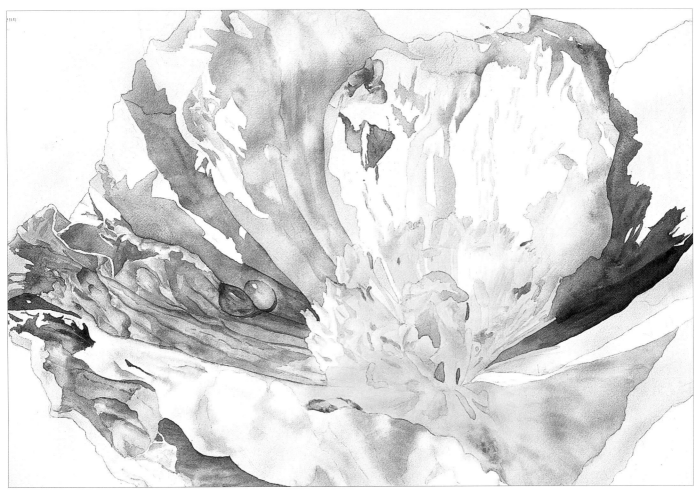

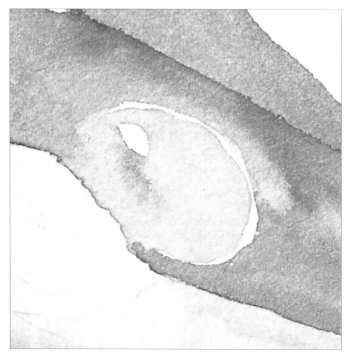

Step 5

Paint the water droplet

Let's add a water droplet for interest. Make sure the oval outline of the drop is still visible from your tracing, then determine your light source. In this painting, the light is coming from the left, which means the highlight will be on the left.

Step 6

Define the droplet

Drop a darker value of the petal color onto the part of the droplet that is closest to the light source. Soften with a damp brush, leaving the other side of the droplet the same value as the petal.

When the paint has dried, paint the cast shadow on the petal, opposite the light source.

Once this has dried you can lift a highlight at the drop's sunlit end.

You can make alterations to watercolor

Don't be afraid to make changes to your painting. I originally painted two large water drops. After studying the painting, I realized the size and shape of the drop on the left did nothing to improve the design. So I made it smaller and less obvious. Watercolor is an extremely flexible medium.

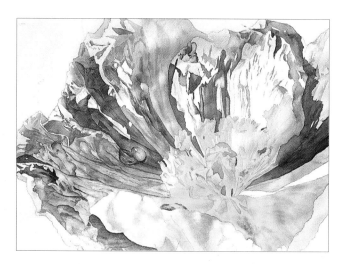

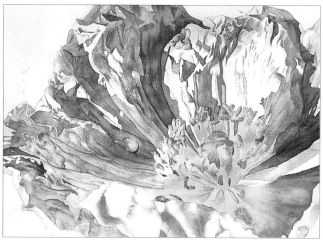

Step 7

Introduce the background

You don't have to paint detailed information in your backgrounds. Instead, try to hint at what might be beyond the flower.

- To achieve this effect, paint washes of pale Scarlet Lake on the lower left of the flower. This will give the impression of other flowers in the background. Light values of the background colors can also be added at various places in the background.

READ ME!

Sleep on it! Once a painting is finished, I wait several days before I sign it. This way, I can make sure that all the final details are to my satisfaction.

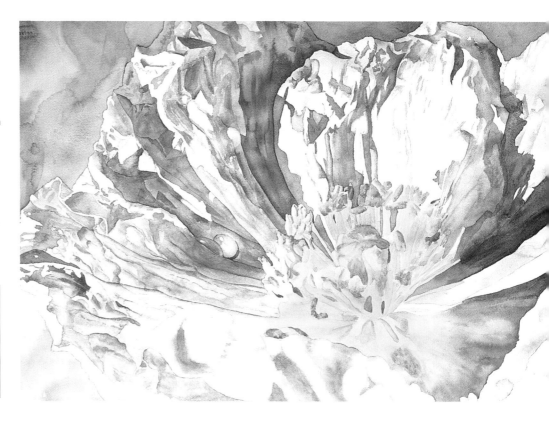

Step 8

Intensify the background darks

When the painting is dry, apply clear water over the passage just painted (this keeps the colors lighter because the background color is painted near or over these colors). Use an unevenly blended mixture of Phthalo Blue, Phthalo Green, Dioxazine Violet, Permanent Alizarin Crimson and Burnt Sienna to paint the background. Add additional washes to achieve the required darkness.

CHECKPOINT

Compare your work with this. How did you manage the washes, edges and layers making up the shadows? Note anything you had a problem with then give it another go!
 Remember, you learn from your mistakes.

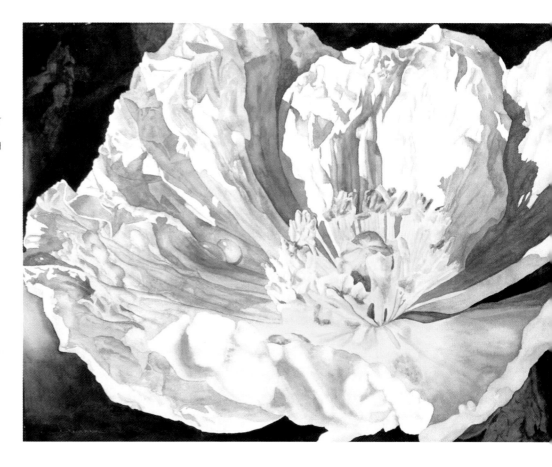

PROJECT 5 BANANA FLOWER

How to paint with primary colors

Choosing colors for your painting is a major step, but it's how you mix your colors that is the true test of a good artist. You don't need every tube of paint the manufacturer offers. This exercise will give you plenty of experience in painting successfully using only the three primary colors: red, yellow and blue.

 Although it's fun to have lots of tubes of color, and it sometimes seems easier to squeeze out a dollop of the "perfect" color than mix the color from scratch, this project will teach you how to create the correct color in a pinch when you don't own a tube of the "perfect" color.

 As before, take the time to read this project through first to make sure you understand the concept and the sequence.

The challenge
- To achieve a great painting using only primary colors.

What you'll learn
- How to mix custom colors from a limited palette.

The techniques you'll use
- large washes
- glazes
- wet-into-wet
- wet-onto-dry
- background washes

Warm and cool primary colors

Everyone knows there are three primary colors red, yellow and blue, but the most useful palette includes six: a warm and a cool version of each of the primary colors. (You'll learn more about pigments and color temperature in Project 8.)

 Using two temperatures of the same color allows you to apply the cooler pigments to the shadows and the warmer ones to the areas in the light. This makes the shadows recede and adds depth to the painting.

 Ultramarine Blue is such a versatile color that you won't need its cooler version, Phthalo Blue, for this particular painting. For the warm yellow, let's go to the extreme and use Raw Sienna.

Warm primaries

Windsor Red

Raw Sienna

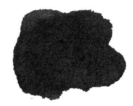

Ultramarine Blue

Cool primaries

Permanent Alizarin Crimson

Lemon Yellow
(Windsor Yellow)

Phthalo Blue
(Green shade)

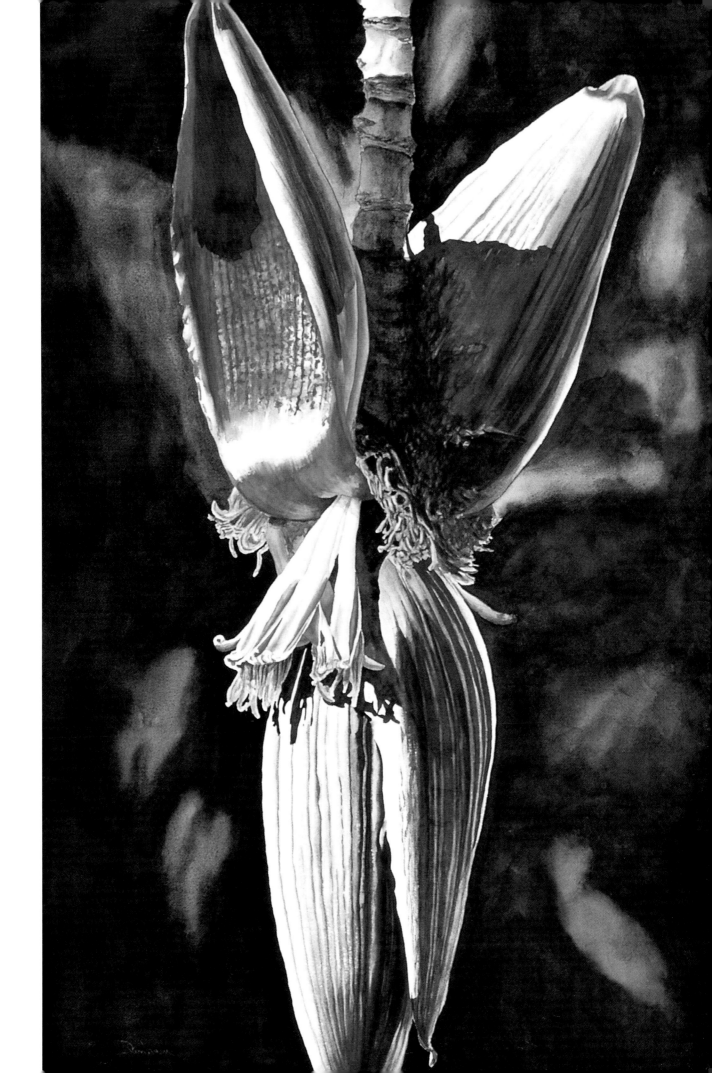

The materials you'll need for this project

Support
I recommend 140lb (300gsm) cold-pressed artist-quality watercolor paper.

Pencils and tracing paper
Use a no. 2 pencil to trace and transfer your design onto watercolor paper. You can also use graphite paper to transfer the drawing. See Step 1 for more information.

Brushes
- no. 2 squirrel-hair
- no. 4 squirrel-hair
- no. 7 squirrel-hair
- no. 12 squirrel-hair
- 2" hake brush
- stiff bristle scrubber

Hairdryer
Use a hairdryer to speed up the drying process. At certain points, such as when applying glazes or painting details, it is essential that your paper is absolutely dry.

Spray bottle
Mist your painting with clean water in a spray bottle to extend your working time, soften edges or add texture.

Watercolors

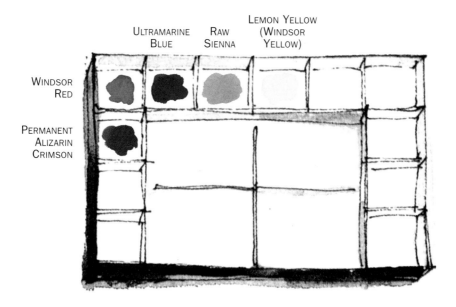

ULTRAMARINE BLUE RAW SIENNA LEMON YELLOW (WINDSOR YELLOW)

WINDSOR RED

PERMANENT ALIZARIN CRIMSON

The center of interest

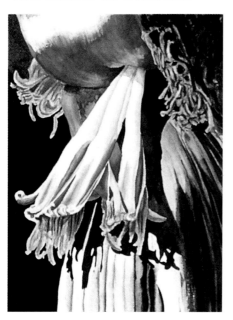

The eye-path

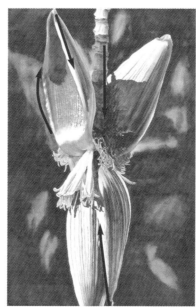

The value scheme

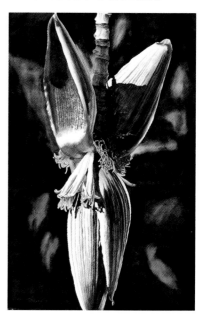

light areas **dark/shadow**

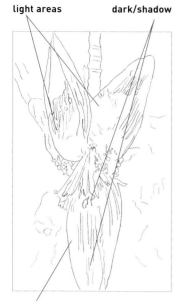

light area

Regard your initial drawing as your map. If you study this drawing carefully and compare it with the finished painting, you will see that I have not just delineated the basic shapes, but also noted some crucial shadows and passages of color and tone.

Step 1
Sketch, photocopy or trace this drawing

In this stage, all we can see is a somewhat confusing, flat mass of line. It is our job to make this flat drawing look three-dimensional.

Sketch, trace or photocopy this drawing. (You can enlarge the drawing on a photocopy machine if you prefer to work on a larger image.) Transfer the design to your watercolor paper using graphite paper, or make your own transfer paper by covering the back of your tracing or photocopy with no. 2 pencil. While you are actually copying the design onto your watercolor paper, trace lightly so you don't ruin the surface of the paper.

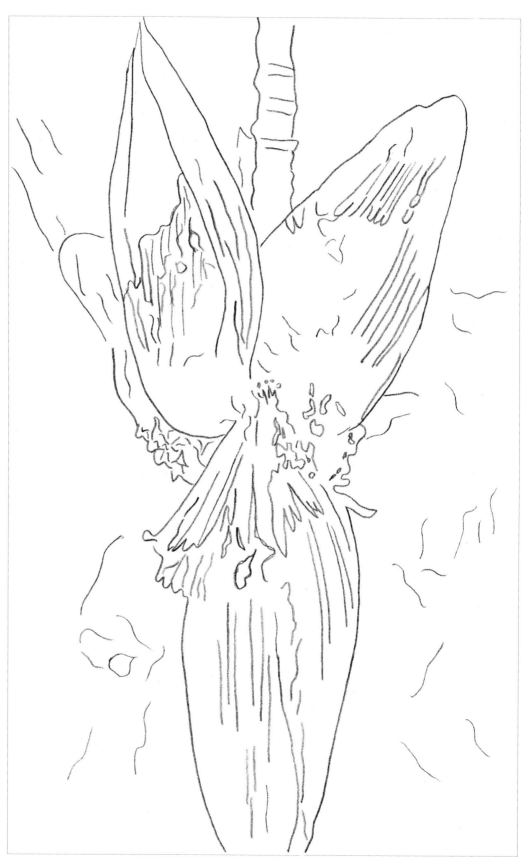

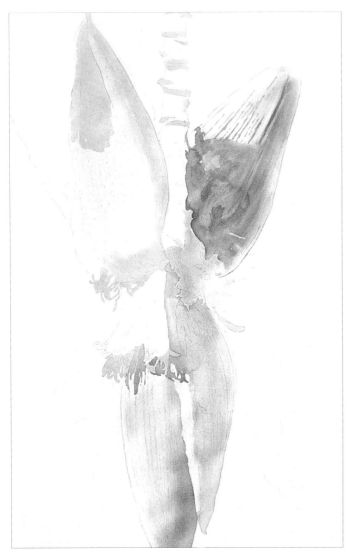

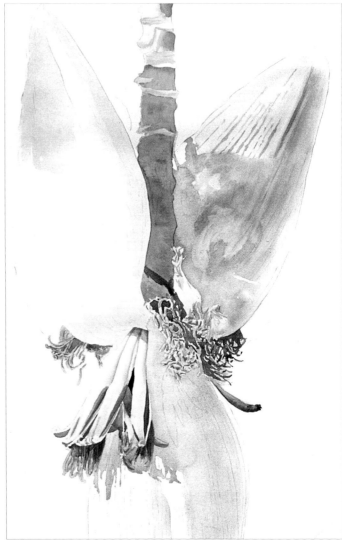

Step 2

Lay in the first washes

- Using Permanent Alizarin Crimson, Ultramarine Blue and Raw Sienna, create a purple mixture that is almost black, then dilute to a pale wash. Apply this mix wet-into-wet to the upper right and lower bract. You can apply a stronger mix to those areas in the shadows.

- To achieve the glow of the sun coming through the bract on the left, use a light Raw Sienna wash. Paint the stamens and dried flower parts with this same wash. We will considerably darken the dried stamens on the right in a later step, leaving touches of the Raw Sienna for the light edges.

> ### READ ME!
> Ultramarine Blue and Raw Sienna are granulating colors, which means they dry with a grainy texture. I love using granulating colors because they create special effects without having to do any additional work.

Step 3

Add color to the stamens and stem

Create a pale mix of Raw Sienna and just a touch of Ultramarine Blue. Apply this to the shaded areas of the tube-like flowers.

- Next, use a mixture of Permanent Alizarin Crimson and Raw Sienna to paint the delicate pinks at the ends.

- The stamens are mainly a darker version of this mix. By adding a touch of Ultramarine Blue you can create the darker values for the shadows. Paint the dried stamens with irregular strokes in a variety of colors — dark purple, toned-down Raw Sienna and some red.

- I had planned to paint this flower using only three tubes of pigment — the warm versions of the primaries. But try as I might, I was unable to create the right shade of green with Raw Sienna and Ultramarine Blue. I needed a cooler yellow, so I mixed Lemon Yellow with the Ultramarine Blue for the perfect green. For the areas in the shadows, add more blue. This is just the underpainting for the stem. We'll darken it more later.

RAW SIENNA ULTRAMARINE BLUE

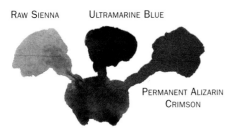

PERMANENT ALIZARIN CRIMSON

RAW SIENNA PERMANENT ALIZARIN CRIMSON

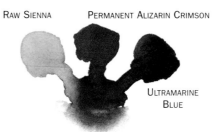

ULTRAMARINE BLUE

ULTRAMARINE BLUE LEMON YELLOW (WINDSOR YELLOW)

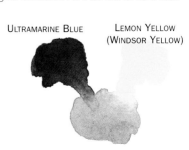

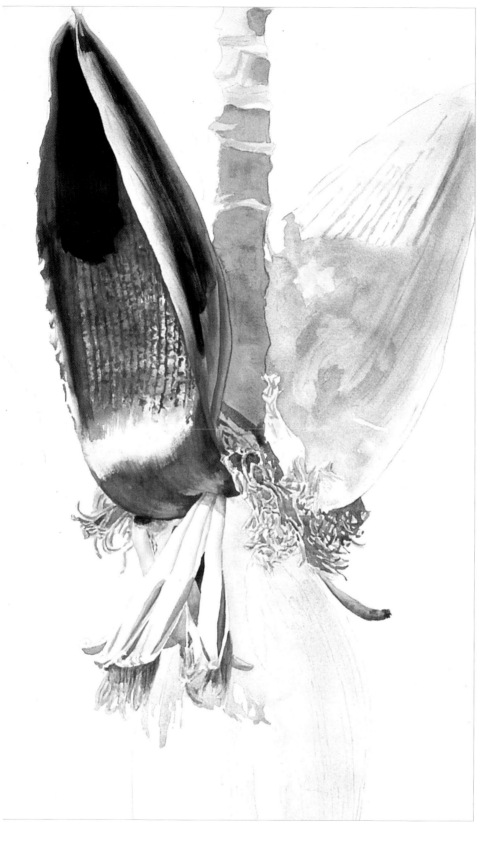

Step 4

Paint the red bract

- Dilute some Permanent Alizarin Crimson, add a touch of Raw Sienna and apply this wash to the right edge of the red bract. When this dries, add a darker version of the same color to create the ribs on the outer edge, softening with clear water where needed.

- On the underside near the flowers, paint a couple of patches of Raw Sienna. Using a strong mix of Permanent Alizarin Crimson and Raw Sienna, paint around the patches of straight Raw Sienna, feathering where the bract turns and catches the light. Leave the white of the paper to create the shine.

- While this section is drying, apply the diluted dark purple mix to the right hand curl of this part of the plant. Add clear water to the inside edge to create the light on the curl.

- The red center is an underpainting of Permanent Alizarin Crimson with a small amount of Raw Sienna. When dry, add a top layer of Windsor Red to intensify and add vibrancy to the color.

- Create the uneven ridges in the center by painting a wiggly line of the two reds. Then, while the paint is still wet, spray it with clear water. Don't overdo it — a hit-and-miss spritz will allow the paint to bleed unevenly, creating the desired texture.

- Paint the shadows with a mix made by adding Ultramarine Blue to Permanent Alizarin Crimson.

READ ME!

To keep the paper flat as I paint, I periodically turn it over, spray it lightly with water and then spread the water around with a big brush. This relaxes the fiber on the back that hasn't gotten wet during painting. I let the paper dry before turning it back over.

RAW SIENNA PERMANENT ALIZARIN CRIMSON

RAW SIENNA ULTRAMARINE BLUE

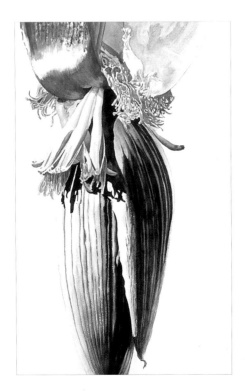 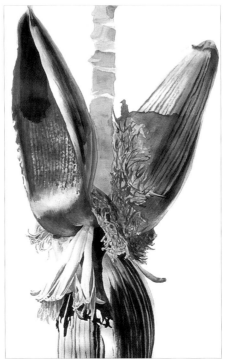 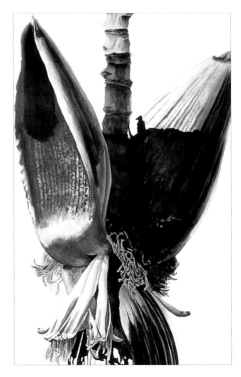

Step 5

Paint the remaining bracts and dried flowers

- Use varying strengths of your dark purple mix to paint the remaining bracts. When they are dry, you can lift out highlights on the top of the ridges using a stiff bristle brush.

- The dried flowers in the shadows are merely random brushstrokes of dark browns, light browns and dark purple. Create a brown by mixing Raw Sienna and Permanent Alizarin Crimson, then add Ultramarine Blue until the right shade is reached. Paint the lighter values first and let them dry. Then add layers of color, ending with the darkest values. Don't try to make sharp edges. This area is not the center of interest, so the edges can be softer and values more similar. As you finish the dried flowers, keep them dark because they are in the shadows.

- Darken the greens on the stem in the shadow and add the dark brown touches that circle the stem with a mix of Permanent Alizarin Crimson, Raw Sienna and a touch of Ultramarine Blue.

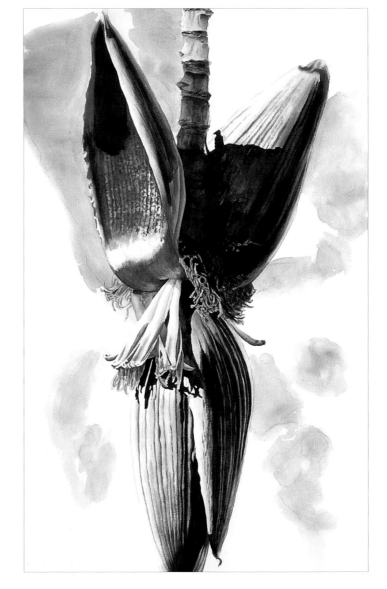

READ ME!

You don't want sharp edges and high contrast in your background. Those features are for the center of interest.

Step 6

Paint the background

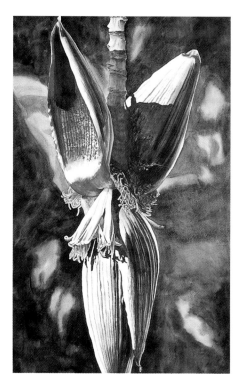

- The first step for the background is to paint random patches of color. Mix Lemon Yellow and Ultramarine Blue for the greens, dropping them in wet-into-wet to create soft edges. Add light brown patches mixed from Raw Sienna and Permanent Alizarin Crimson. Vary the mixes as you go to add interest to the background.

- Let this first layer dry before adding the darker tones. Be sure not to completely cover these initial areas of light color. By allowing them to "peek" through the dark background, you keep a potentially plain area from becoming boring.

Step 7

Introducing darks

- Using a large brush, mix a variety of darks using Ultramarine Blue, Lemon Yellow and Permanent Alizarin Crimson. Try to keep the mixes on the cool side to create depth in your background. Before you apply these mixes to your paper, dampen the colors you previously painted so you'll get soft edges as you paint around them. Remember to mix big puddles of color so you won't run out.

READ ME!

Patience! Patience is probably the most important painting skill you can develop. There will be times when you think you have failed, nothing looks right, and you want to scrap the whole project. *Don't.* A painting slowly emerges in time. It does not happen instantly.

CHECKPOINT

It usually takes two to three coats to achieve the degree of darkness you see in this background, so don't panic if it looks too light after the first pass.

You have just completed an entire painting using only the primary colors — red, yellow and blue. Who needs all those tubes?

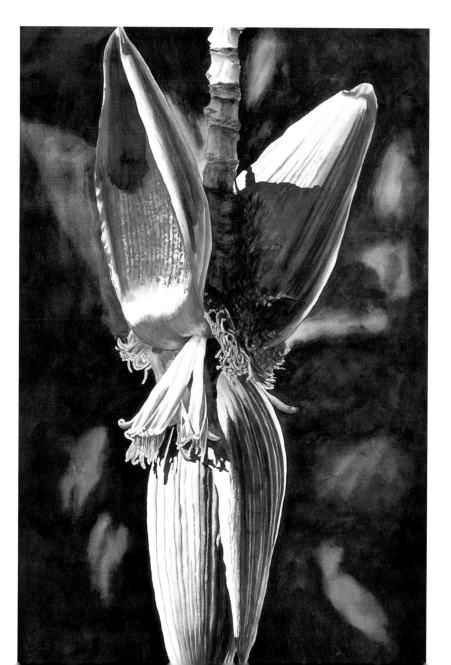

PROJECT 6 HIDE 'N SEEK

You can create drama with value contrast

Are you a wishy-washy watercolorist? Don't be afraid to use color and value to enhance the beauty of your paintings. If you can use the entire range of values, you will have a knockout design. Many artists will tell you to use only the high, medium or low range of values. What fun is that? I push values to the max. I like to get my darks really dark. The contrast pulls you into the painting, making you look to see what's in the shadows.

By now I hope you're in the habit of reading through the entire project before you start!

The challenge

- To use lots of pigment to create deep colors.

What you'll learn

- The dramatic effects of strong values of local color.

Techniques you'll use

- large washes
- glazes
- wet-onto-dry
- wet-into-wet

Local color

Local color is the actual color of an object as you would describe it in everyday language. For instance, the local color of a lemon is yellow the local color of an orange is orange.

Value scale

A value scale consists of a set number of gradations from value 1 (white) to black. Artists frequently use scales with 3, 5, 7 or 10 steps to help them visualize value gradations. I've used a 5-step scale below to show how I incorporated the whole range of values in this painting.

There are, of course, an infinite number of actual value steps between white and black, and you will use far more than 5 values in your paintings. If you squint at your painting, you will find you can assess the values much better.

Use the entire range of values in your paintings

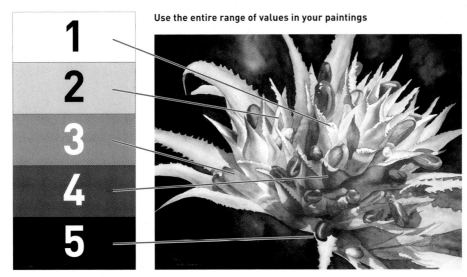

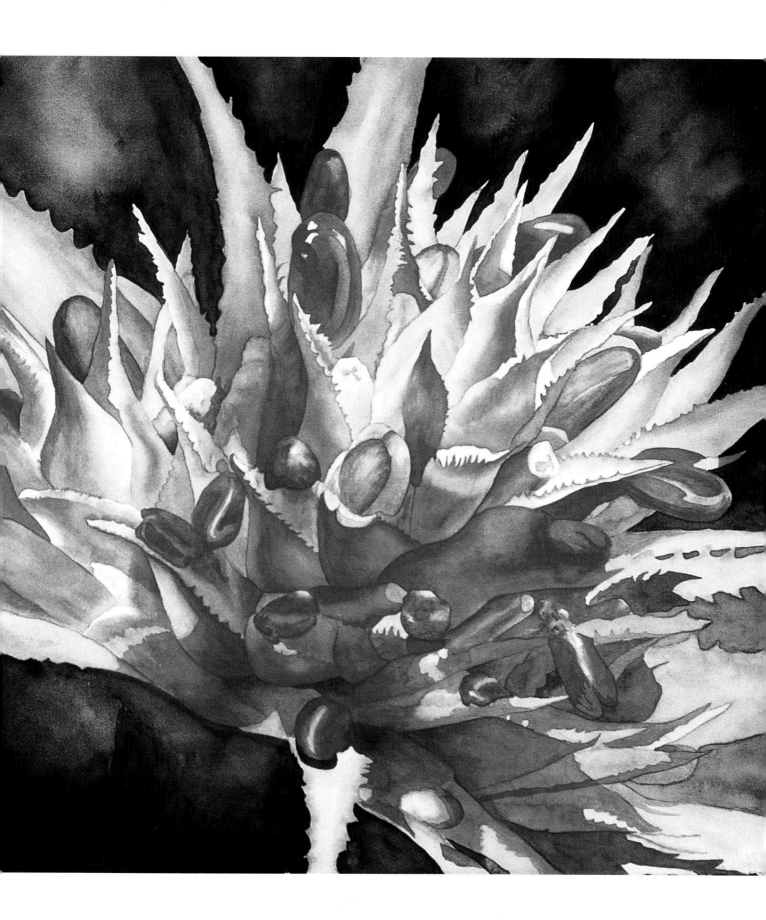

The materials you'll need for this project

Support
I recommend 140lb (300gsm) cold-pressed artist-quality watercolor paper.

Pencils and tracing paper
Use a no. 2 pencil to trace and transfer your design onto watercolor paper. You can also use graphite paper to transfer the drawing. See Step 1 for more information.

Brushes
- no. 2 squirrel-hair
- no. 4 squirrel-hair
- no. 7 squirrel-hair
- no. 8 sable
- stiff bristle brush

Hairdryer
Use a hairdryer to speed up the drying process. At certain points, such as when applying glazes or painting details, it is essential that your paper be absolutely dry.

Watercolors

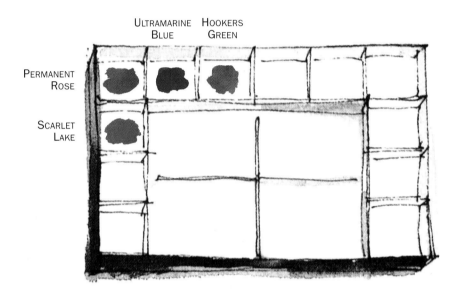

ULTRAMARINE BLUE HOOKERS GREEN

PERMANENT ROSE

SCARLET LAKE

The center of interest

The eye-path

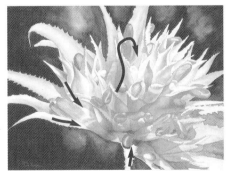

The value scheme

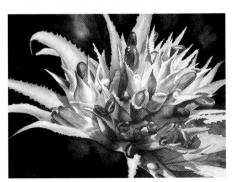

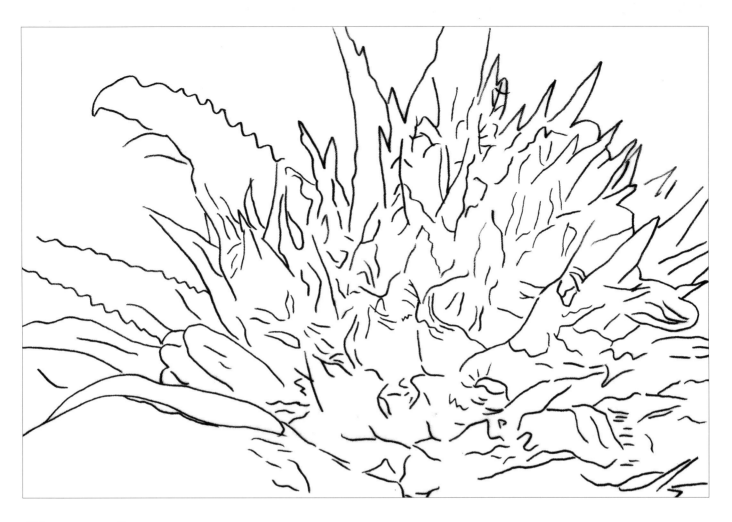

Step 1

Sketch, trace or photocopy this drawing

In this stage, all we can see is a somewhat confusing, flat mass of line. It is our job to make this flat drawing look three-dimensional.

Sketch, trace or photocopy this drawing. (You can enlarge the drawing on a photocopy machine if you prefer to work on a larger image.) Transfer the design to your watercolor paper using graphite paper, or make your own transfer paper by covering the back of your tracing or photocopy with no. 2 pencil. While you are actually copying the design onto your watercolor paper, trace lightly so you don't ruin the surface of the paper.

light areas

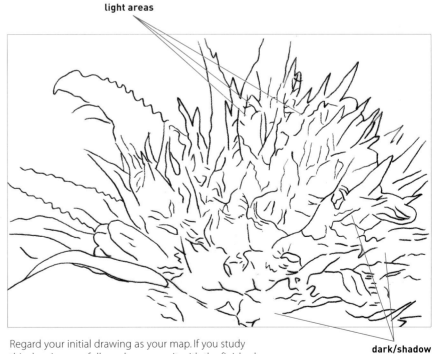

dark/shadow

Regard your initial drawing as your map. If you study this drawing carefully and compare it with the finished painting, you will see that I have not just delineated the basic shapes, but also noted some crucial shadows and passages of color and tone.

Step 2

Paint and shade the flower spikes

- Create a pale mix of Scarlet Lake and Permanent Rose and cover all the light pink areas of the flower.

- While this initial wash is still damp, add a darker mix of the same colors to the tips of the flower spikes and the shaded areas. To keep the painting interesting, make sure you vary the mixture so the different areas of color have subtle differences.

- The heart of this flower lies in the dark undersides of the petals. To paint these areas of deep value, use less water, more pigment and add Ultramarine Blue to your mixture. Allow the paint to dry and layer more color on top to strengthen the dark values.

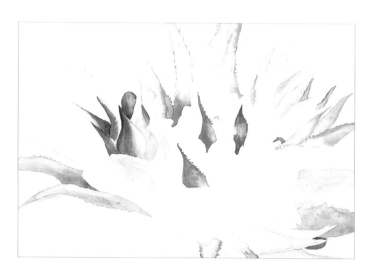

PERMANENT
ROSE

SCARLET
LAKE

READ ME!

Use a clean, damp (almost dry) brush to remove excess water that builds up on the edge of a wash or paper. This will prevent a blossom from forming.

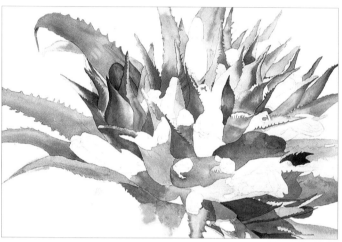

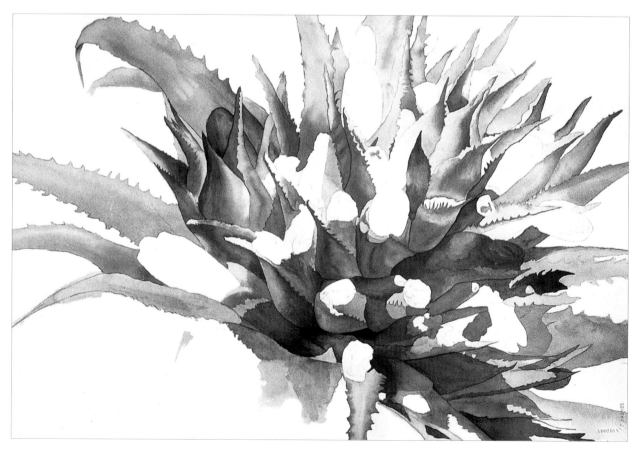

Step 3

Paint the flower buds

- Once the flower spikes are dry, use Ultramarine Blue with a small amount of Permanent Rose to paint the blue buds.

- Paint the deep pink buds with a strong mix of Permanent Rose and Scarlet Lake plus a touch of Ultramarine Blue. Make sure to leave white areas for highlights where the sun is hitting the flower.

SCARLET LAKE

PERMANENT ROSE

ULTRAMARINE BLUE

Step 4

Evaluate the dark values

- Take a good look at your painting so far. Reds tend to dry much lighter than they look when wet. You may find it necessary to add more color to attain the rich, deep pinks in the shadows of the flower. Remember: using a full range of values adds depth and realism.

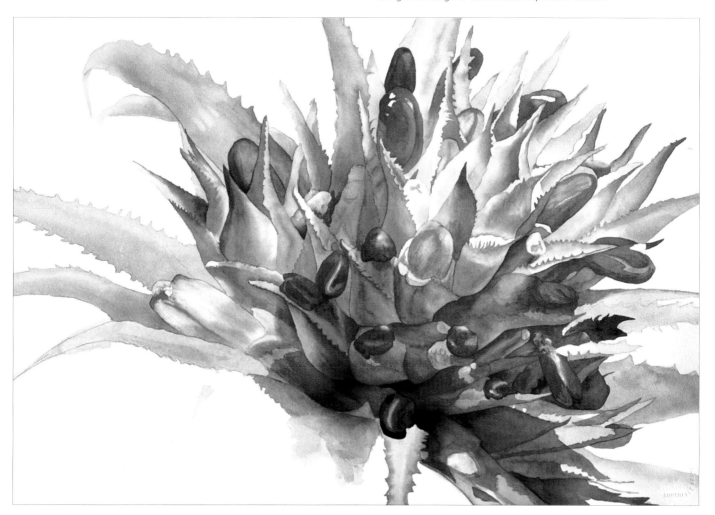

Step 5

Paint the background

- Wet the areas in the background where you will drop in light mixtures of Permanent Rose with touches of Hookers Green.

- Once this is dry, go over the entire background with various mixtures of Hookers Green, Ultramarine Blue and Permanent Rose.

- Soften edges around the light values to subtly blend into the darks. By using different mixes of Permanent Rose and Hookers Green you will create color unity in the painting.

HOOKERS GREEN ULTRAMARINE BLUE PERMANENT ROSE

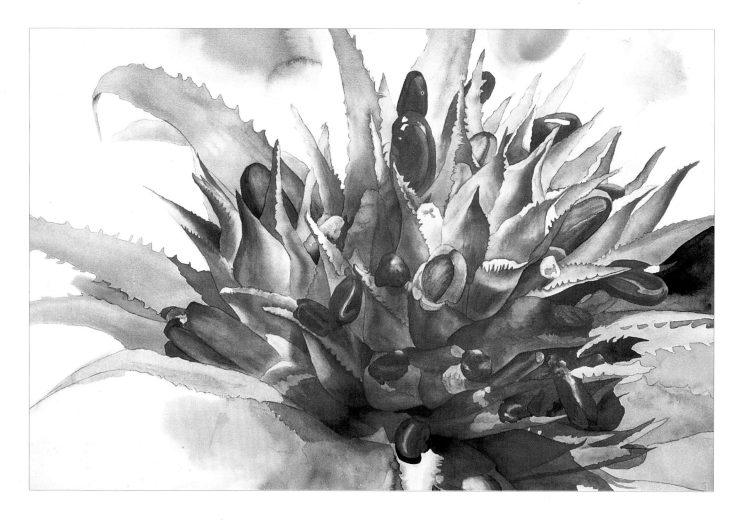

Step 6

Evaluate the tonal range

● Once the dark background is in place, step back and look again at the values in the flower. Tone down areas that are too bright with a pale wash of the base flower color. Areas that aren't bright enough can be lifted with a stiff brush.

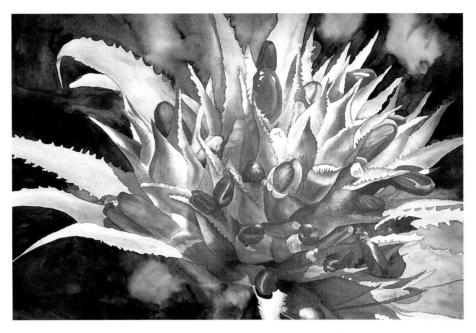

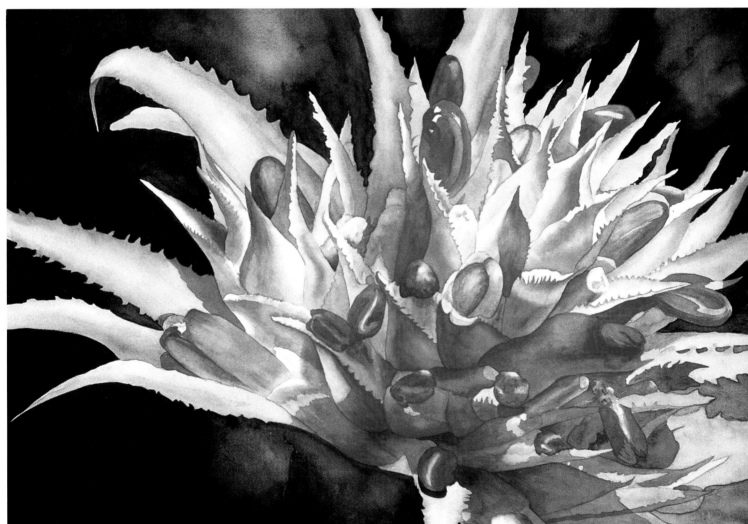

CHECKPOINT

Did you understand the concept of tonal value?
Do you see now that color has tonal value?

PROJECT 7 ORANGE FRAPPÉ

How to paint flowers that glow

When the early morning or late afternoon sun hits a flower, the petals glow. Recreating this look in a painting adds drama and lifts it above the ordinary. To get this glow, it's imperative to preserve the white of your paper in the sunlit areas. It is the contrast of the extremely light, sunlit areas of the flower against the darker values not touched by the sun that creates the glowing effect. You can tone the whites down later with a very pale wash, but wait until the background is established and you can step back and truly assess the values in your painting.

Don't forget to read this project through before you begin.

The challenges
- To create the effect of brilliant sunlight reflecting off and shining through your flower petals.

What you'll learn
- How to leave the white of the paper for a glowing effect.
- How to use values to create light.

The techniques you'll use
- large washes
- glazes
- wet-onto-dry
- wet-into-wet

Color and contrast

Unlike the other paintings in this book, this is painted with predominately one color — orange. Using a monochromatic color scheme presents certain challenges: with only one colour you must keep the viewer's interest with texture, nuances and variation. It's much easier to keep the eye involved and moving over the painting when you incorporate several colors into the design.

The success of this painting relies much on the contrast between the brightly lit petals and the petals in shadow. Usually, shadows are painted in cool colors so they will visually recede. Orange, however, is a warm color. To make the orange shadows recede, I cooled them by adding Ultramarine Blue to the deep orange shadow mixture. Ultramarine Blue is biased toward red, making it a warmer color than, for instance, Manganese Blue. It works well with orange to create rich, dark, receding shadows.

Image orientation

Always be open to thinking outside the box. I painted this flower, start to finish, in a horizontal format. I was pleased with this orientation. However, I always prop up my completed paintings in the studio and look at them on and off for a couple of days to see if I want to make any last-minute changes. Something bothered me about this one, but I couldn't quite put my finger on it. A friend came over for dinner and agreed that something was amiss — we tried turning the painting and discovered it looked much better in a vertical orientation. I always advise artists to look at their paintings from different angles, but I forgot to heed my own advice!

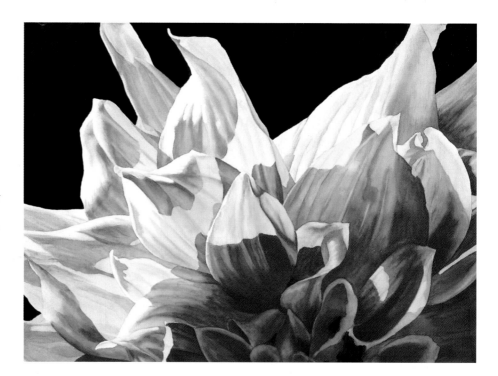

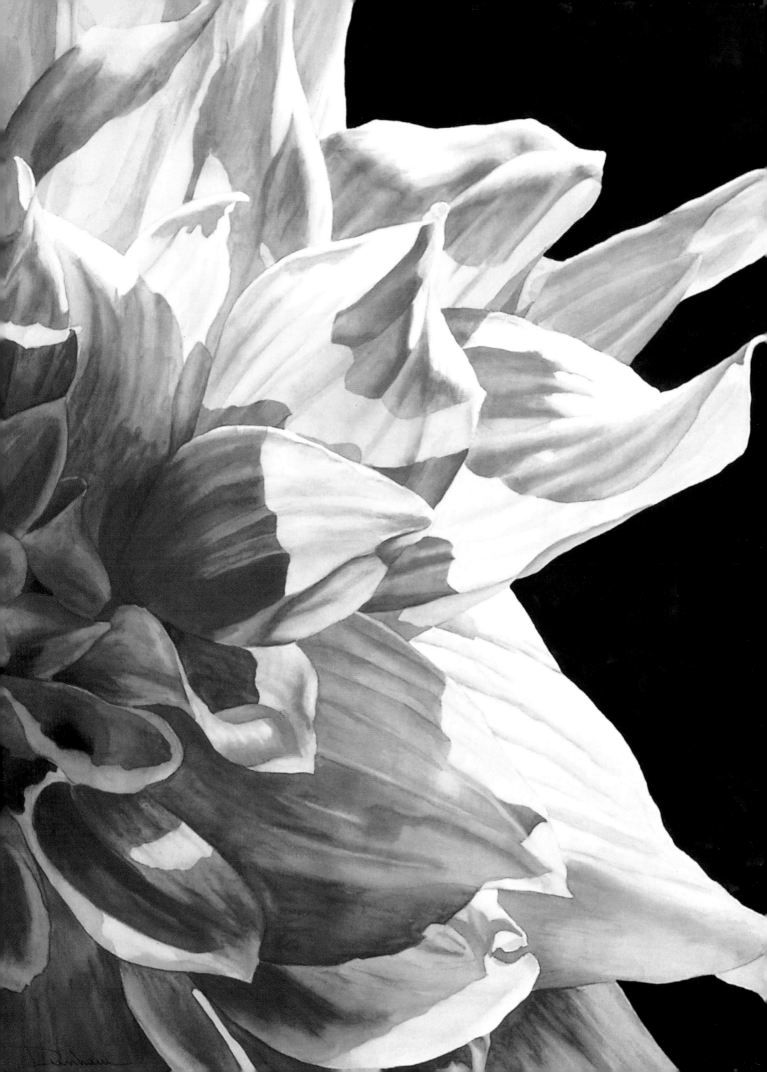

The materials you'll need for this project

Support

I recommend 140lb (300gsm) cold-pressed artist-quality watercolor paper.

Pencils and tracing paper

Use a no. 2 pencil to trace and transfer your design onto watercolor paper. You can also use graphite paper to transfer the drawing. See Step 1 for more information.

Brushes

- no. 2 squirrel-hair
- no. 4 squirrel-hair
- no. 7 squirrel-hair
- no. 6 sable
- stiff bristle scrubber

Masking fluid

If you don't feel confident painting around the lightest areas, protect them with an application of masking fluid.

Hairdryer

Use a hairdryer to speed up the drying process. At certain points, such as when applying glazes or painting details, it is essential that your paper is absolutely dry.

Watercolors

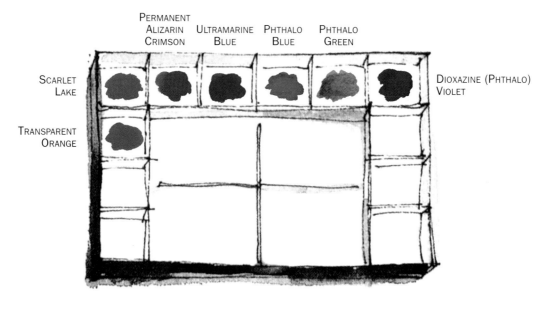

SCARLET LAKE

TRANSPARENT ORANGE

PERMANENT ALIZARIN CRIMSON

ULTRAMARINE BLUE

PHTHALO BLUE

PHTHALO GREEN

DIOXAZINE (PHTHALO) VIOLET

The center of interest

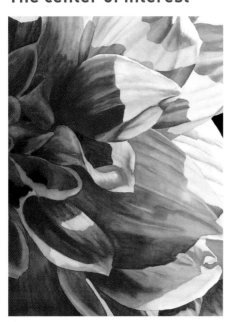

The eye-path

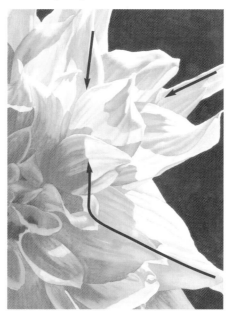

The value scheme

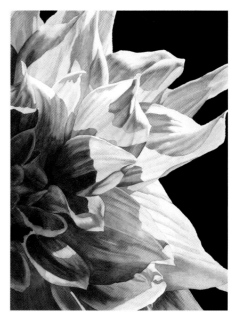

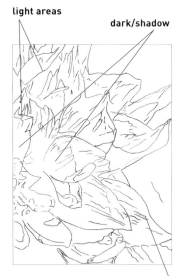

light areas

dark/shadow

light areas

Regard your initial drawing as your map. If you study this drawing carefully and compare it with the finished painting, you will see that I have not just delineated the basic shapes, but also noted some crucial shadows and passages of color and tone.

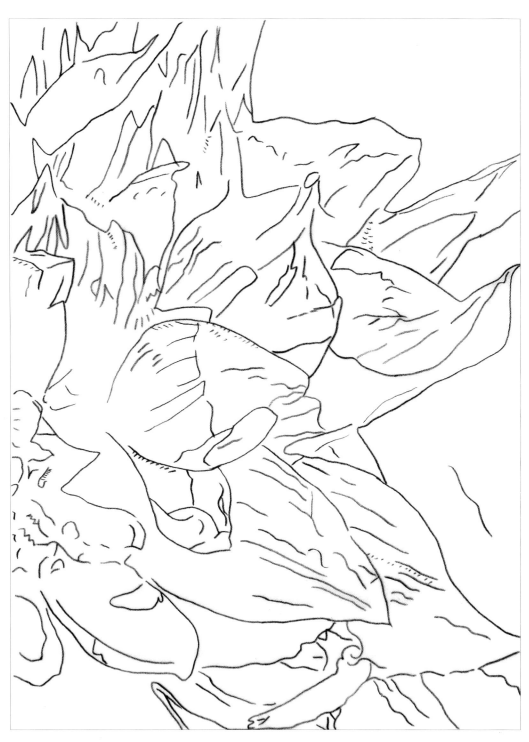

Step 1

Sketch, photocopy or trace this drawing

In this stage, all we can see is a somewhat confusing, flat mass of line. It is our job to make this flat drawing look three-dimensional.

Trace or photocopy this drawing. You can enlarge the drawing on a copy machine if you prefer to work on a larger image. Transfer the design to your watercolor paper using graphite paper, or make your own transfer paper by covering the back of your tracing or photocopy with no. 2 pencil. While you are actually copying the design onto your watercolor paper, trace lightly so you don't ruin the surface of the paper.

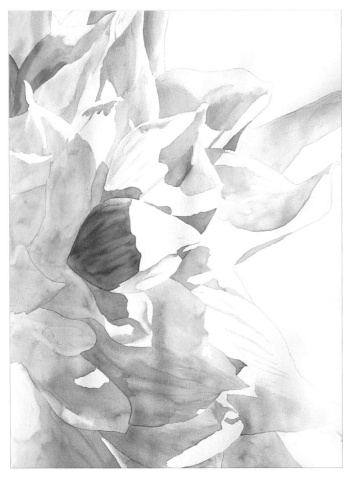

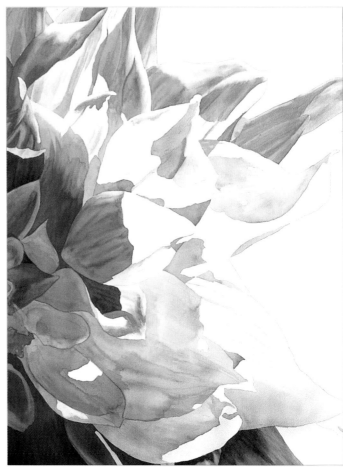

Step 2

Lay in the first washes

- Apply a very pale wash of Transparent Orange with just a touch of Scarlet Lake to all of the petals. Avoid the white areas. The trick to creating petals that glow and sparkle is being able to save your whites. You can always paint over the areas you think are too light later, but it's impossible to retrieve them once painted. Remember: Lose the white, lose the painting.

Step 3

Paint the petals

- Start shaping the petals with layered applications of Transparent Orange mixed with a touch of Scarlet Lake. Where the petal turns and becomes almost white, dampen the paper and let the colors bleed.

- For the darker passages, add a touch of Ultramarine Blue to the previous mix. Paint the darkest petals at the bottom of the flower with a mix of Transparent Orange, Scarlet Lake and Permanent Alizarin Crimson. Remember: Don't touch those whites!

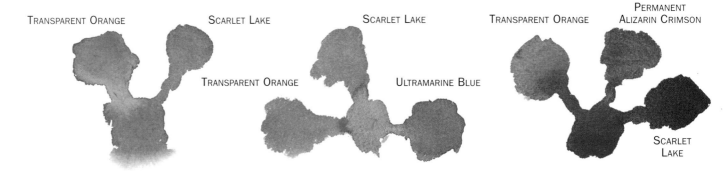

TRANSPARENT ORANGE SCARLET LAKE

TRANSPARENT ORANGE

SCARLET LAKE

TRANSPARENT ORANGE PERMANENT ALIZARIN CRIMSON

ULTRAMARINE BLUE

SCARLET LAKE

READ ME!

Use large brushes for large areas. It's quicker and the paint applies more evenly.

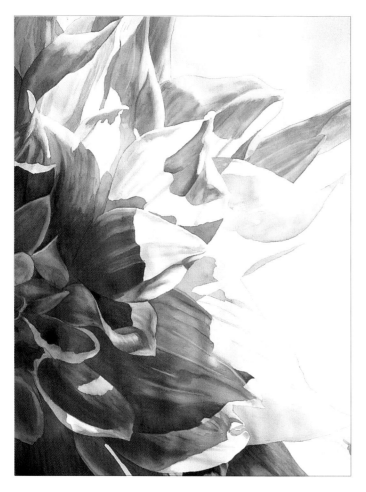

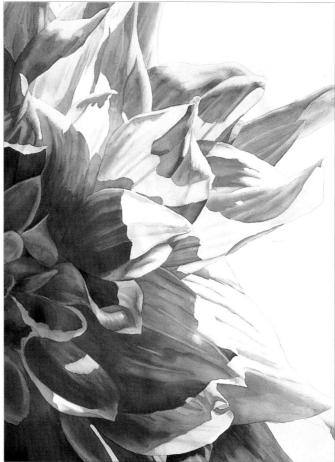

Step 4

Create the glow with value contrasts

- It isn't just the white of the paper that makes the transparent glow of the flower — it's the contrast in values. To set the tone of bright sun shining through and on top of the petals, you must establish very dark as well as very light values. Dark mixtures of Transparent Orange, Permanent Alizarin Crimson and a touch of Ultramarine Blue will give you those deep values in the center of the flower. If you need to lift lights out of a darker area, use a stiff bristle scrubber.

Step 5

Apply strategic pale washes

- So far we've avoided painting the white areas. Now we have to decide which white areas to leave and which ones we will paint with a very pale wash of Transparent Orange. Study the petals. Those catching the direct sun should be left white, while those areas where the sun shines right through the petals will need the pale wash. This represents the glow of a strong light coming through a translucent petal, washing out most of the local color.

READ ME!

This flower is challenging because of the many values of orange needed to create the look of sunlight and shadow. The orange is intense, and your eyes can only take so much at one time. Give them a break every now and then. Get up, go outside, offer your eyes relief for a while. You'll be amazed how much easier it is when you return.

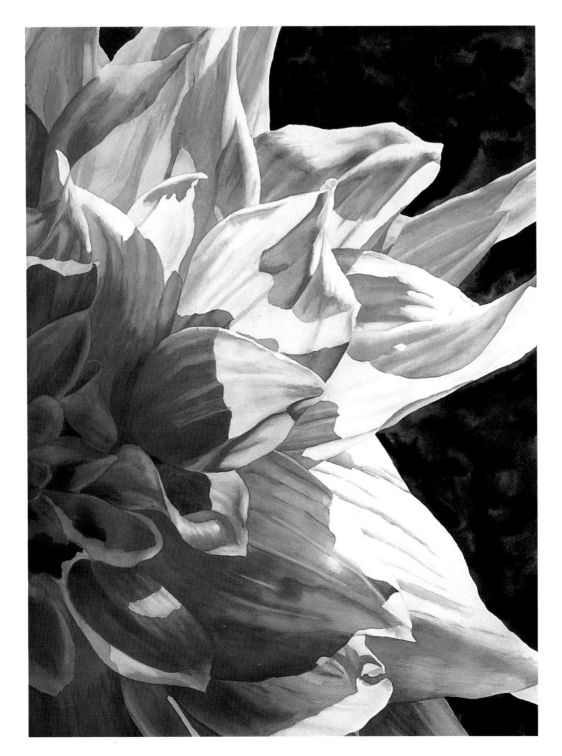

CHECKPOINT

Now you can see how to create the illusion of three dimensions by using value contrast.

Step 6

Paint the background

The background for this painting is very simple. The area to be painted is small and only uses three colors: Phthalo Blue, Phthalo Green and Dioxazine Violet. These three colors are all staining, dark colors, which make a very rich black. It should take at least two coats to achieve the deep black. Don't try to do it all in one coat.

- Once the background is dry, re-evaluate the orange petals. You may need to add additional pale washes of Transparent Orange to those parts of the petals not in full sun.

PHTHALO GREEN

PHTHALO BLUE

DIOXAZINE (PHTHALO) VIOLET

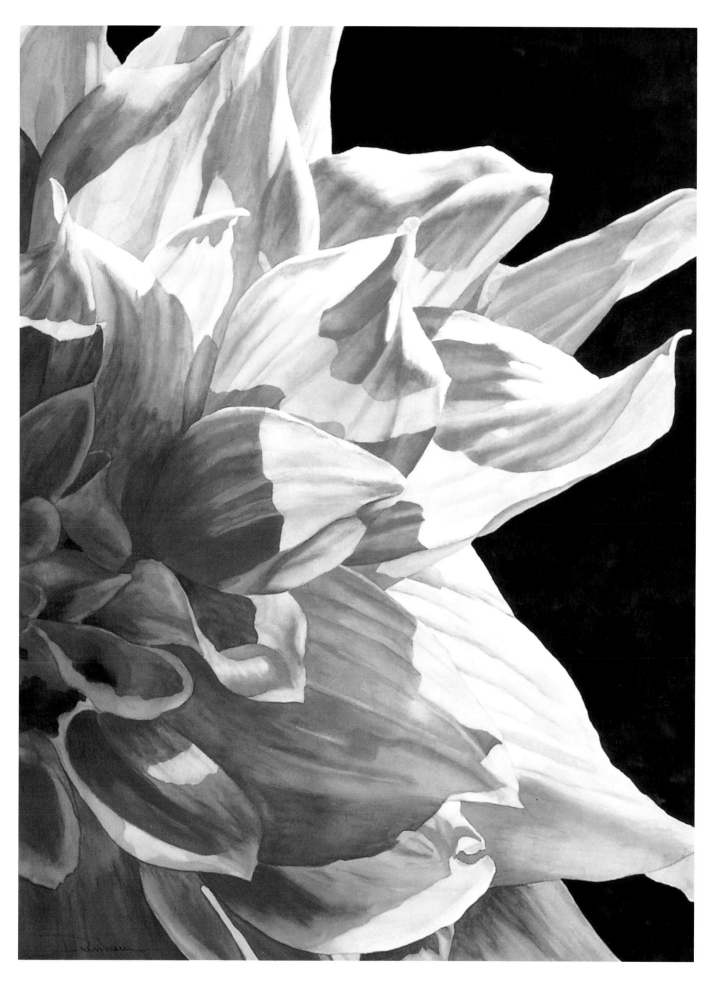

PROJECT 8 TAOS HOLLYHOCKS

Paint color into white flowers

White is my favorite color to paint. That's right — white flowers have color, and I'm going to show you what to look for when you paint them. For instance, shadows on white flowers aren't gray — they're a lively mix of colors that add excitement and drama to your painting.

As usual, read the entire project through before you start.

The challenges

- To preserve your whites. Resist the temptation to cover all surfaces of the paper with paint. It will tease you. Don't give in!
- To create colorful shadows. The shadows are what tells us the flower is white.

What you'll learn

- Shadows come in many colors, particularly on white flowers. The more varied they are, the more interesting the flower becomes.

The techniques you'll use

- background washes
- glazes
- masking
- wet-onto-dry
- wet-into-wet

READ ME!

Rather than mask the white areas in my painting, I paint around them. This allows for a much more natural edge. However, for extremely small highlights or light areas in a dark image, I will occasionally use masking fluid. After the surrounding area is painted and the masking fluid is removed, the line left is extremely sharp and unnatural. This can be corrected by softening the dry edge with a damp brush — a stiff brush for staining colors and a softer brush for non-staining pigments.

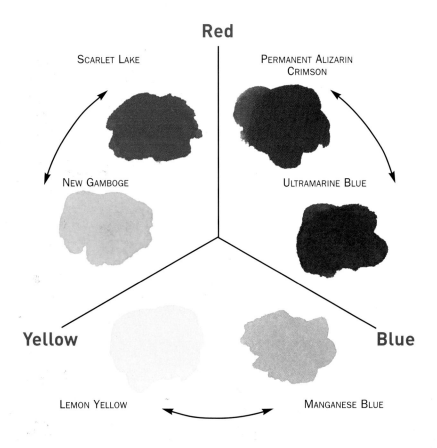

Red

SCARLET LAKE

PERMANENT ALIZARIN CRIMSON

NEW GAMBOGE

ULTRAMARINE BLUE

Yellow

Blue

LEMON YELLOW

MANGANESE BLUE

Important facts about color

Warm and cool colors

Proper use of color temperature can create depth in your flower.

Cool colors appear to recede, while warm colors advance. Shadows tend to be cool and the center of interest warm. The eye will usually travel to the warmer areas of a painting, so try to warm up your focal point whenever you can.

Color bias

In general, red, orange and yellow are considered warm colors. Blue and violet are cool. Green can be either.

In terms of paint pigments, however, every color has both a warm and a cool version. In fact, it is virtually impossible to purchase a pure primary without even a hint of another color in it.

Cool yellows have blue in them, and warm yellows lean toward red. Warm blues have a red component while cool blues have yellow. Cool reds are biased toward blue, and warm reds lean toward yellow.

The chart at left shows the bias of popular watercolor pigments. For instance, Scarlet Lake is a warm red biased to yellow. Permanent Alizarin Crimson is a cool red, biased to violet. Keep the color temperatures of your pigments in mind, especially when painting shadows and your center of interest.

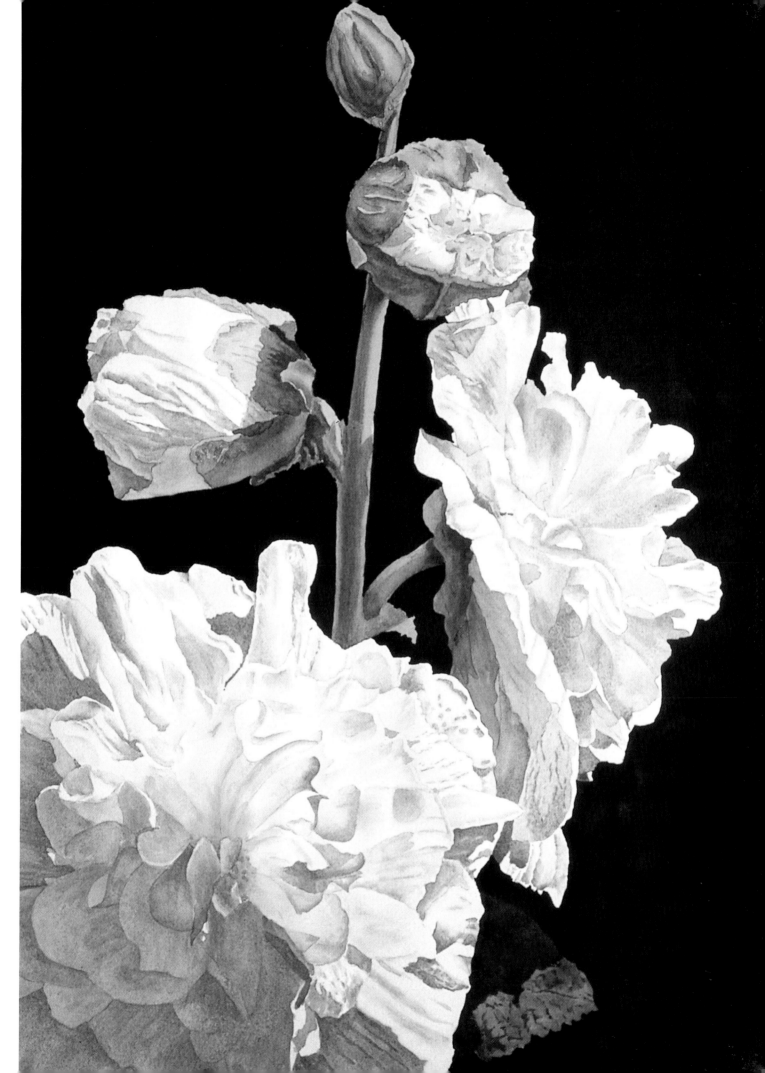

The materials you'll need for this project

Support
I recommend 140lb (300gsm) cold-pressed artist-quality watercolor paper.

Pencils and tracing paper
Use a no. 2 pencil to trace and transfer your design onto watercolor paper. You can also use graphite paper to transfer the drawing. See Step 1 for more information.

Brushes
- no. 2 squirrel-hair
- no. 4 squirrel-hair
- no. 7 squirrel-hair
- large wash brush

Masking fluid
If you don't feel confident enough to paint around the lightest areas, protect them with an application of masking fluid.

Hairdryer
Use a hairdryer to speed up the drying process. At certain points, such as when applying glazes or painting details, it is essential that your paper be absolutely dry.

Watercolors

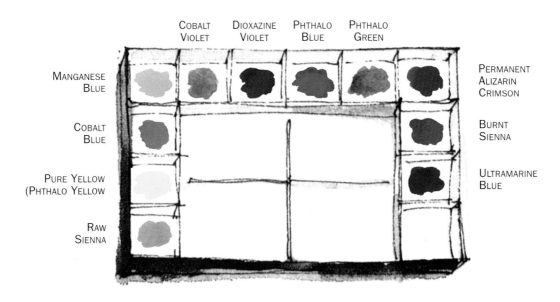

MANGANESE BLUE

COBALT BLUE

PURE YELLOW (PHTHALO YELLOW

RAW SIENNA

COBALT VIOLET

DIOXAZINE VIOLET

PHTHALO BLUE

PHTHALO GREEN

PERMANENT ALIZARIN CRIMSON

BURNT SIENNA

ULTRAMARINE BLUE

The center of interest

The eye-path

The value scheme

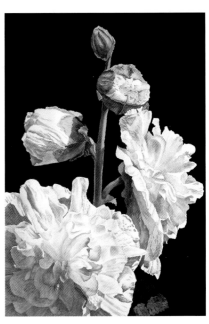

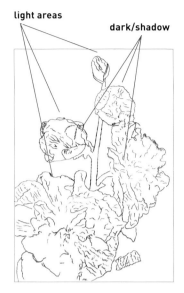

light areas dark/shadow

Regard your initial drawing as your map. If you study this drawing carefully and compare it with the finished painting, you will see that I have not just delineated the basic shapes, but also noted some crucial shadows and passages of color and tone.

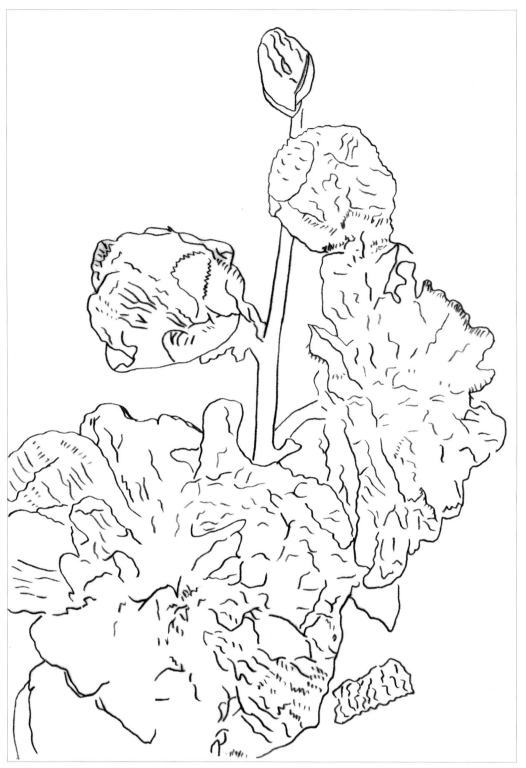

Step 1

Sketch, photocopy or trace this drawing

In this stage, all we can see is a somewhat confusing, flat mass of line. It is our job to make this flat drawing look three-dimensional.

Sketch, trace or photocopy this drawing. (You can enlarge the drawing on a photocopy machine if you prefer to work on a larger image.) Transfer the design to your watercolor paper using graphite paper, or make your own transfer paper by covering the back of your tracing or photocopy with no. 2 pencil. While you are actually copying the design onto your watercolor paper, trace lightly so you don't ruin the surface of the paper.

Step 2

Lay in pale washes

- Lay in pale washes for the flower centers using Raw Sienna combined with Pure Yellow.

- For the stems and buds, create pale green mixtures with Pure Yellow and Cobalt Blue.

- While the initial green washes are still damp — but not shiny wet — drop in a darker green mix for the shadows. If you do this when the first wash is too wet, the dark colors will bleed into the first wash, entirely eliminating the light areas.

READ ME!

Adding a thin underpainting of Raw Sienna to those parts of the flower that are affected by sunlight gives petals the desired sunlit glow.

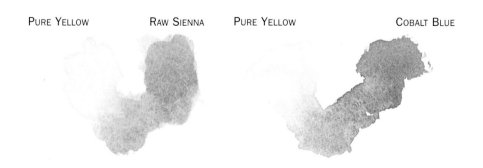

PURE YELLOW RAW SIENNA PURE YELLOW COBALT BLUE

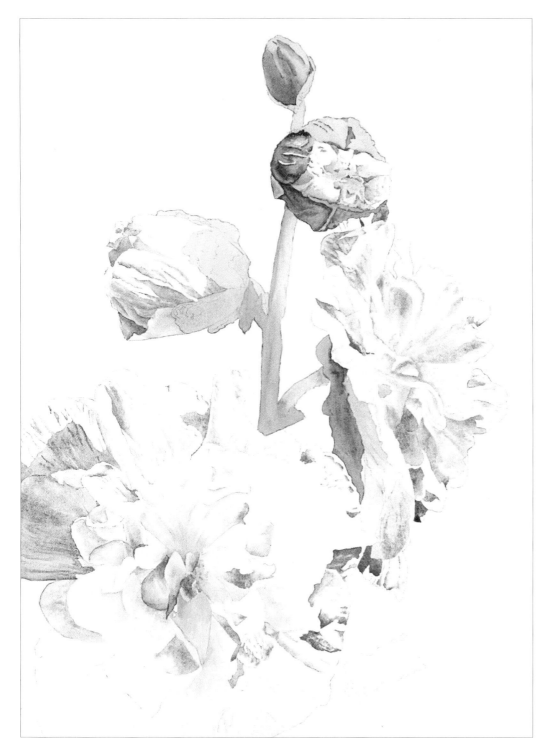

Step 3

Lay in the shadows

- Now we come to the fun part. The more shadows you paint, the more the flower begins to grow.

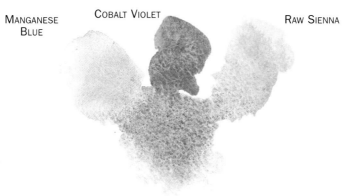

MANGANESE BLUE COBALT VIOLET RAW SIENNA

Step 4

Refine the shadows

- Darken the green stems and leaves with more intense mixtures of Cobalt Blue and Pure Yellow.

- Strengthen shadows in the petals as needed using the same mixture you initially used for the shadows (Manganese Blue, Cobalt Violet and Raw Sienna). Don't be timid.

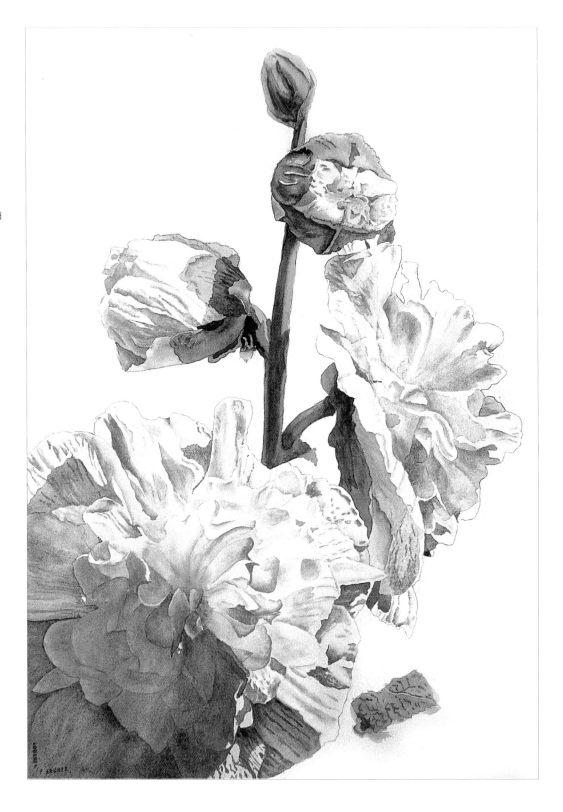

READ ME!

The darker the shadows, the whiter the flower becomes. The contrast between light and dark helps make your painting interesting.

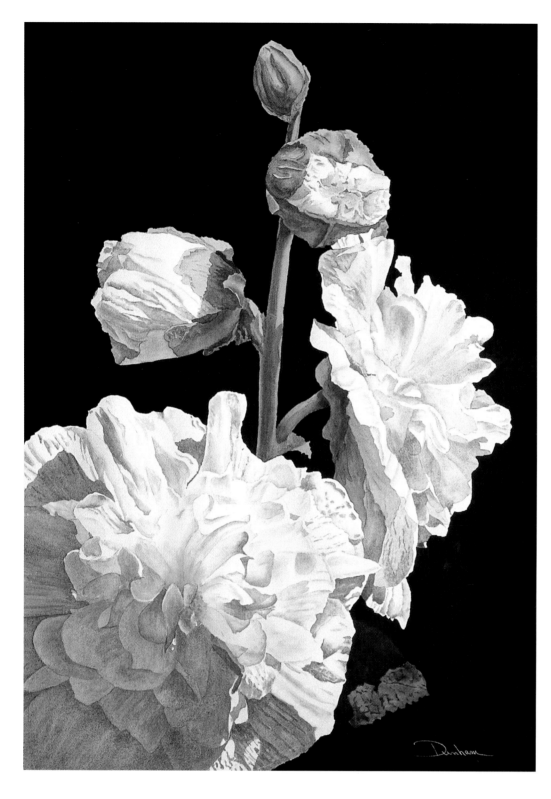

Step 5
Paint the background

A dark background makes the flower jump off the page. I particularly like using this effect. You must paint dark backgrounds last. If you paint the background first, you will inevitably touch the background with your wet brush, allowing the dark color to bleed into an area you intended to keep light.

- You can get a really good dark background using mixes of Dioxazine Violet, Phthalo Blue, Phthalo Green, Permanent Alizarin Crimson and touches of Burnt Sienna and Ultramarine Blue. Your background will be more interesting if you allow these colors to remain slightly unmixed on your palette.

- Try using a large mop brush and a very wet mix of pigments to cover large areas. I usually paint two or three layers of these dark colors to achieve the intense depth I require in my paintings. Make sure each layer is thoroughly dry before applying the next.

- Once the painting is complete, step back and look at all the relationships between all the values. Then go back and darken key areas as needed to create more depth in the petals.

CHECKPOINT

How did you go with this project? Can you see how effective dark can be to emphasize light?

> **READ ME!**
>
> Shadows appear darker than they are until the background is painted. Note the difference between the images on these two pages. One has a white background, the other dark. That's the only difference.

PROJECT 9 DESERT ROSE

You CAN paint yellow flowers

Creating a dramatic painting using yellow is challenging. Yellow is inherently light in value, so developing the darks and shadows without dulling the color, can test the skills of even the best of artists.

But you're equal to the task! Again, read the entire project carefully before you start painting.

The challenge

- To create depth in a yellow flower without dulling the color.

What you'll learn

- That there is more than one way to create dark passages when painting with yellow.
- How to drop in color wet-into-wet to create smooth transitions
- How to mix other colors with yellow

Techniques we'll use

- large washes
- glazes
- wet-onto-dry
- wet-into-wet
- masking

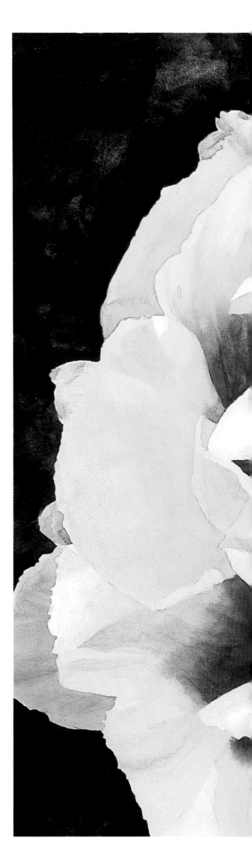

Building warm values of yellow

LEMON YELLOW PURE YELLOW PURE YELLOW + RAW SIENNA PURE YELLOW + BURNT SIENNA

Building cool values of yellow

LEMON YELLOW LEMON YELLOW + MANGANESE BLUE NEW GAMBOGE + MANGANESE BLUE NEW GAMBOGE + COBALT BLUE

Values of pure yellow

DILUTED PURE YELLOW PURE YELLOW PURE YELLOW + NEW GAMBOGE PURE YELLOW + MORE NEW GAMBOGE PURE NEW GAMBOGE

78

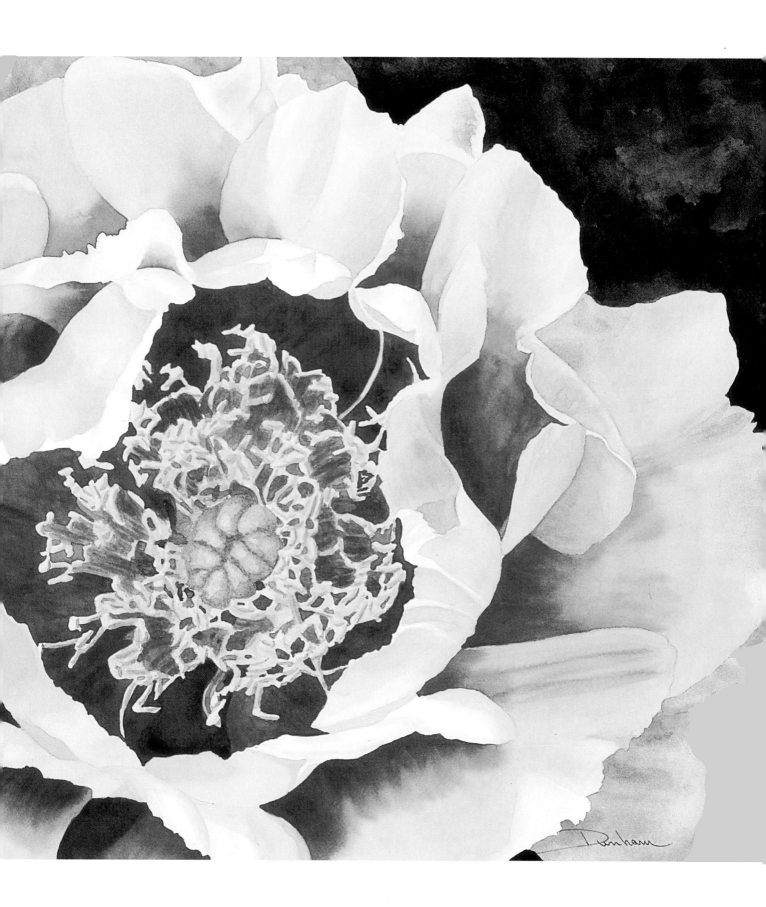

The materials you'll need for this project

Support
I recommend 140lb (300gsm) cold-pressed artist-quality watercolor paper.

Pencils and tracing paper
Use a no. 2 pencil to trace and transfer your design onto watercolor paper. You can also use graphite paper to transfer the drawing. See Step 1 for more information.

Brushes
- no. 2 squirrel-hair
- no. 4 squirrel-hair
- no. 7 squirrel-hair
- 2" hake wash brush
- stiff bristle scrubber

Masking fluid
If you don't feel confident painting around the lightest areas, protect them with an application of masking fluid.

Hairdryer
Use a hairdryer to speed up the drying process. At certain points, such as when applying glazes or painting details, it is essential that your paper be absolutely dry.

Watercolors

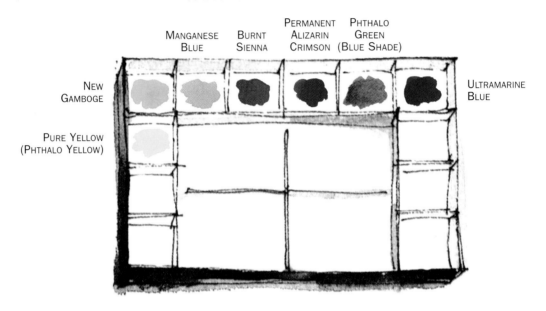

MANGANESE BLUE BURNT SIENNA PERMANENT ALIZARIN CRIMSON PHTHALO GREEN (BLUE SHADE)

NEW GAMBOGE

PURE YELLOW (PHTHALO YELLOW)

ULTRAMARINE BLUE

The center of interest

The eye-path

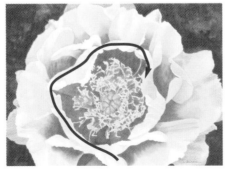

The value scheme

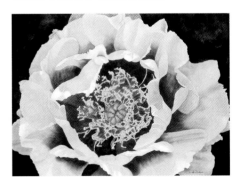

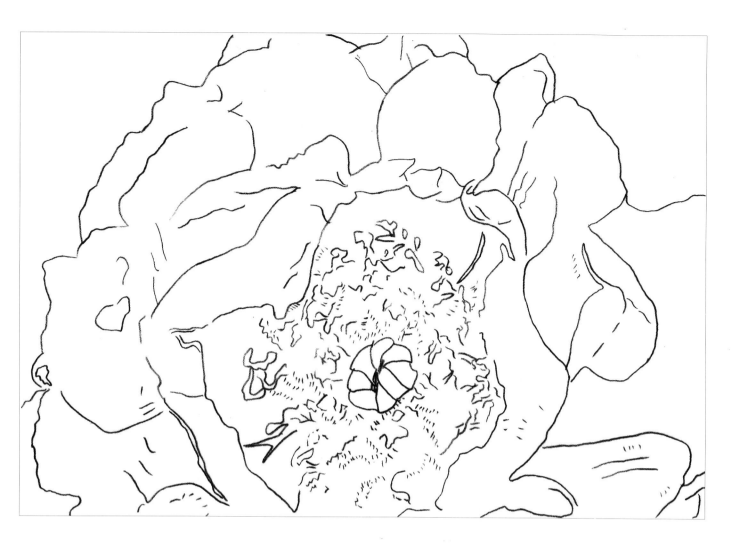

Step 1

Sketch, trace or photocopy this drawing

In this stage, all we can see is a somewhat confusing, flat mass of line. It is our job to make this flat drawing look three-dimensional.

Sketch, trace or photocopy this drawing. You can enlarge the drawing on a photocopy machine if you prefer to work on a larger image. Transfer the design to your watercolor paper using graphite paper, or make your own transfer paper by covering the back of your tracing or photocopy with no. 2 pencil. While you are actually copying the design onto your watercolor paper, trace lightly so you don't ruin the surface of the paper.

light areas

dark/shadow

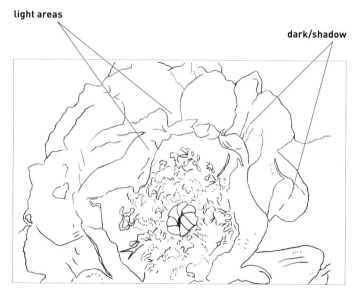

Regard your initial drawing as your map. If you study this drawing carefully and compare it with the finished painting, you will see that I have not just delineated the basic shapes, but have also noted some crucial shadows and passages of color and tone.

Step 2

Cover the flower with pale yellow washes

Study this picture to see the areas that you need to keep white. If you don't feel confident about painting around the white areas, protect them with masking fluid before you start painting. Let the fluid dry thoroughly before beginning your washes.

- Cover the entire flower, including the green center, with a pale wash of Pure Yellow. There is a yellow undertone to the center. Painting a yellow wash in that area now will help you achieve the correct color when you layer green later.

- Paint around the light and white areas during this stage. It's all right if a little paint bleeds into the light areas because the wet-into-wet technique creates soft, light edges that won't affect the final image.

PURE YELLOW

NEW GAMBOGE
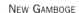

READ ME!

The easiest way to achieve an even wash is to do it wet-into-wet. Before you start, make sure you have more than enough color mixed and ready to use. If you run out before finishing, some areas you have already painted will dry before you can mix more. This will create hard edges.

READ ME!

To keep your paper from buckling when you are painting large washes, wet both sides of the paper first and smooth the paper with a damp sponge onto your support or tabletop. A hake brush is the best tool for laying down large washes. It holds a lot of water and allows you to cover large areas quickly.

Step 3

Start to shade the petals

- Shade each petal separately to keep the integrity of edges and color. For the mid-value petals use Pure Yellow. On the darker petals use New Gamboge. So far, we haven't added any other colors to the yellows. Use pure yellows for as long as you can to keep them from becoming muddy.

- Continue working on each petal one at a time. While the paper is still damp from the initial shading, drop a mixture of Burnt Sienna and Permanent Alizarin Crimson onto the bottom of the petal. The dark tone will blend with the yellow, creating a soft transition between the colors.

- Use a mixture of Pure Yellow and Manganese Blue to paint the cooler shadows. Don't get carried away with too much blue, just make sure you have a rich cool yellow.

- For petal areas that are in more light but need to be a darker value to show shape, use New Gamboge. Mix it with Pure Yellow in the transition areas between colors.

- Use a combination of New Gamboge and Manganese Blue with a touch of Burnt Sienna to create the darker values.

Try to use the unusual mixture of Burnt Sienna and Manganese Blue to create the translucent look in certain areas of the petals. This color combination only works if you keep it light to medium in value.

PURE YELLOW MANGANESE BLUE

BURNT SIENNA PERMANENT ALIZARIN CRIMSON

READ ME!

When working with yellows, keep your water clean. Yellow is very easily dulled by dirty water.

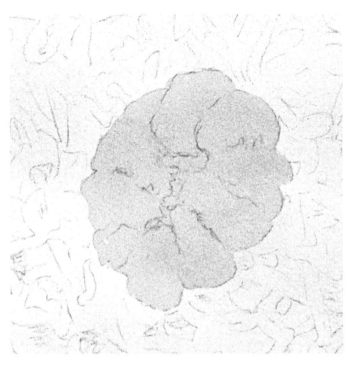

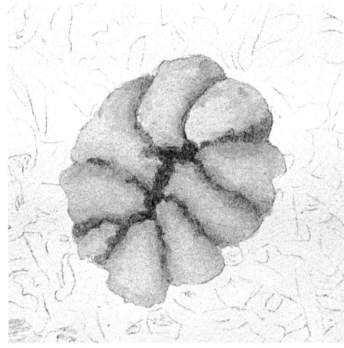

Step 4

Paint the flower center

- Apply a wash of green made with Pure Yellow and Manganese Blue to the pistils (green center) of the flower.

- As this starts to dry, strengthen the green mixture, adding a little Burnt Sienna to darken the ridges. Add this color to the pistils while they are still damp to create the soft edges needed to show form.

Step 5

Paint the stamens

- Paint the area around and underneath the stamens with a mixture of Burnt Sienna and Permanent Alizarin Crimson. If you used masking fluid on the stamens, remove it now, but wait until the paint is completely dry or you will tear the paper.

- Darken the stamens with a diluted mix of Burnt Sienna and Permanent Alizarin Crimson. Keep some of the stamen tips light and make others dark with a mix of New Gamboge and a touch of Burnt Sienna. Then darken the stamen bases more with Burnt Sienna.

PURE YELLOW MANGANESE BLUE

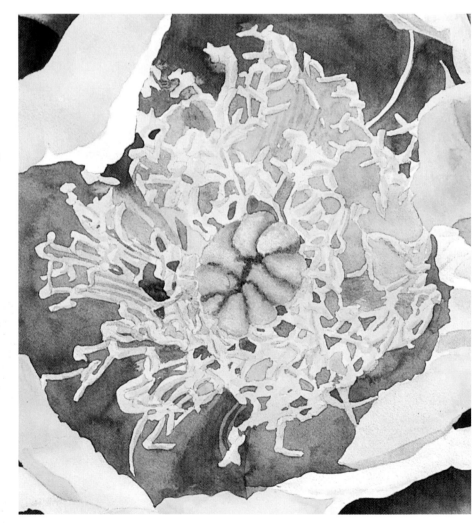

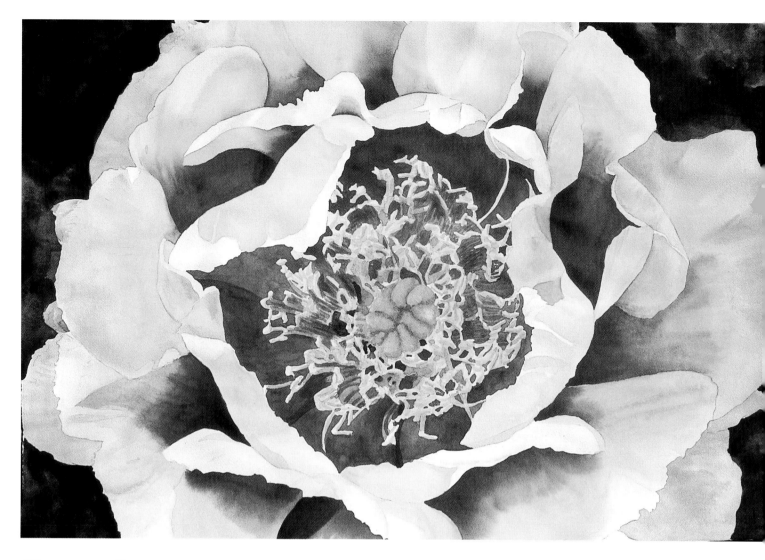

Step 6

Paint the background

- Start painting the background with a mix of Phthalo Green and Ultramarine Blue. After the first application, check your values. I looked at the values in the petals in my painting and decided I needed to create more medium-dark values to accent the highlights on the petal tips. Where necessary, I lifted out color with a stiff brush to add more highlights.

- Next, use a mixture of Ultramarine Blue and Burnt Sienna to create a black to apply over the first layer of the background. To create an uneven, interesting look, apply the paint with the side of your brush.

- Tone down the green center by going over the entire green area with a diluted wash of the black background mixture.

PHTHALO GREEN ULTRAMARINE BLUE

BURNT SIENNA ULTRAMARINE BLUE

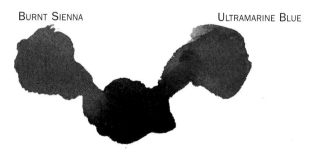

CHECKPOINT

Remember what you learned previously — To make the lights look lighter, make your darks darker.

Create stunning contrast with complementary colors

Complementary colors are those opposite each other on the color wheel: blue and orange, yellow and purple, red and green. In a sense, a complementary color scheme uses all the primary colors. For instance, if your first color is a red, the complement will be a green — a mix of blue and yellow. This orchid has delicate yellow-green outer petals that contrast with the vibrant magenta throat. Placed next to each other like this, complementary colors are stunning.

 As before, please read the project through before you start painting.

The challenges
- To paint with a limited palette.

What you'll learn
- The visual properties of complementary colors.
- The properties of complementary colors when mixed.

The techniques you'll use
- large washes
- glazes
- wet-onto-dry
- wet-into-wet

Getting the most out of complementary colors

This painting uses a subtle variation of the red/green complementary color scheme. The red is the magenta of the throat, and the green is the yellow-green of the petals.

 Complementary colors add life to your painting. Where the two colors meet, an effect called vibration occurs. This excites the eye, attracts the viewer and says "look here." Adjoining complementary colors also brighten each other. If the color you're using doesn't look bright enough or have the kick you want, paint its complement next to it.

 A complementary color scheme can separate your background from your subject, especially if you choose a cool, dark color for the background and its warm, bright complement for the subject. Cool darks recede and warm, bright colors advance.

 Working with a very limited palette challenges the artist to mix colors rather than use them from the tube. If you want a color to look darker or more gray, you can usually add its complement. Mixing a color with its complement is a good way to create shadow colors.

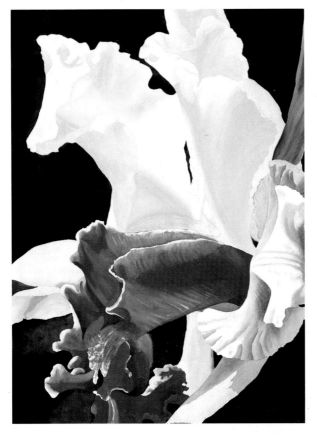

The same picture, without the color complements

Using complementary colors is an easy way to create drama and excitement in your painting. When complements are placed next to each other, they act as a beacon to the eye. They draw attention the same way high value contrast does. Your eyes are attracted to the greatest contrast in a picture, whether it be a contrast of value or of color.

 Notice how the subtle magentas in the background become more obvious when the entire flower is green. The magenta up next to the green draws your attention. With the center petal a bright magenta, those complementary tones in the background are not as noticeable.

The materials you'll need for this project

Support

I recommend 140lb (300gsm) cold-pressed artist-quality watercolor paper.

Pencils and tracing paper

Use a no. 2 pencil to trace and transfer your design onto watercolor paper. You can also use graphite paper to transfer the drawing. See Step 1 for more information.

Brushes

- no. 2 squirrel-hair
- no. 4 squirrel-hair
- no. 7 squirrel-hair
- no. 12 squirrel-hair
- stiff bristle scrubber

Hairdryer

Use a hairdryer to speed up the drying process. At certain points, such as when applying glazes or painting details, it is essential that your paper be absolutely dry.

Watercolors

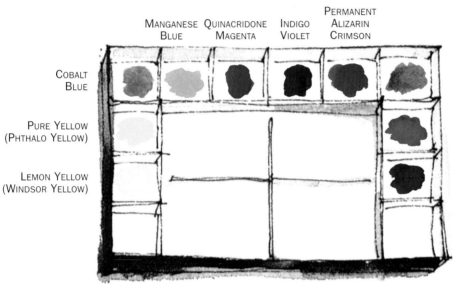

MANGANESE BLUE QUINACRIDONE MAGENTA INDIGO VIOLET PERMANENT ALIZARIN CRIMSON

COBALT BLUE

PURE YELLOW (PHTHALO YELLOW)

LEMON YELLOW (WINDSOR YELLOW)

PHTHALO GREEN (BLUE SHADE)

PHTHALO BLUE (GREEN SHADE)

DIOXAZINE (PHTHALO VIOLET)

The center of interest

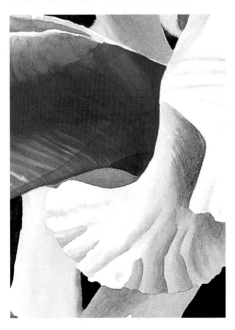

The eye-path

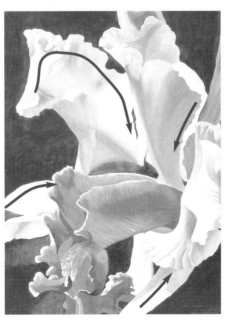

The value scheme

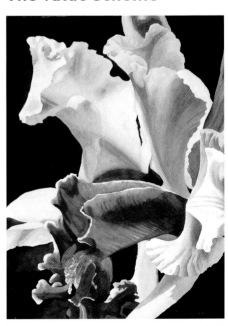

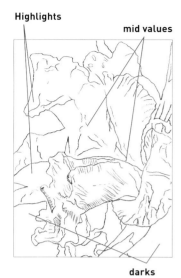

Highlights

mid values

darks

Regard your initial drawing as your map. If you study this drawing carefully and compare it with the finished painting, you will see that I have not just delineated the basic shapes, but also noted some crucial shadows and passages of color and tone.

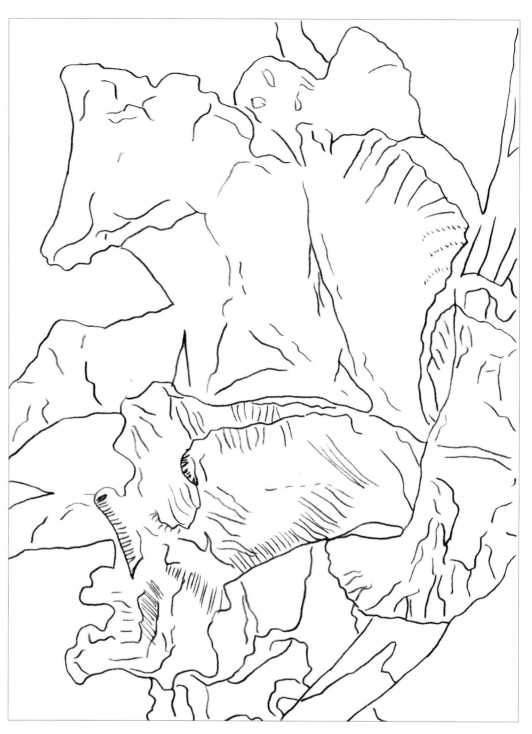

Step 1

Sketch, photocopy or trace this drawing

In this stage, all we can see is a somewhat confusing, flat mass of line. It is our job to make this flat drawing look three-dimensional.

Trace or photocopy this drawing. You can enlarge the drawing on a copy machine if you prefer to work on a larger image. Transfer the design to your watercolor paper using graphite paper, or make your own transfer paper by covering the back of your tracing or photocopy with no. 2 pencil. While you are actually copying the design onto your watercolor paper, trace lightly so you don't ruin the surface of the paper.

Step 2

Paint the yellow and green petals

- Mix Lemon Yellow with a very small amount of Cobalt Blue to create a bright yellow-green. Dilute this and apply a wash to the outer petals.

- Add more Cobalt Blue to darken this mixture and paint some of the shaded areas.

- There are a couple of areas where you need to use a warmer yellow: the lower petal on the left, in the lower area of the top left petal and right under the throat in the center of the image. Use Pure Yellow for those areas.

- Once the first wash is dry, continue by painting the shadows. In order to achieve a really bright green, mix Pure Yellow with Manganese Blue and apply to those areas receiving more light. Where you need darker greens, add more pigment — a mix of Cobalt Blue, Manganese Blue and Lemon Yellow works well.

- Parts of the petals have a slight reddish touch. This is accomplished by adding a touch of Quinacridone Magenta to your green mix. Don't add too much — reds are very potent colors.

- Leave the center, magenta petals for later. Magenta is a very strong color. If you painted this area first, then accidentally touched it with a wet brush while painting the green petals, the magenta would bleed and make a real mess. This is where patience counts.

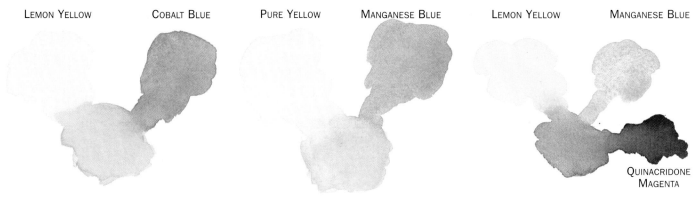

LEMON YELLOW COBALT BLUE PURE YELLOW MANGANESE BLUE LEMON YELLOW MANGANESE BLUE

QUINACRIDONE MAGENTA

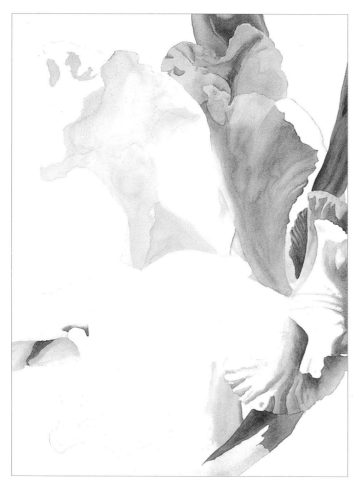
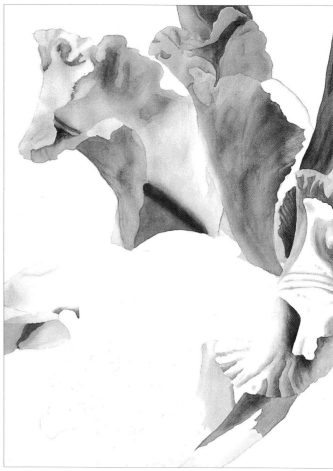

Step 3

Refine the shadows

- Once all the outer petals have been painted and are dry, re-evaluate the shadow areas. To make them cooler and darker, apply a light wash of Cobalt Blue. This wash will enhance the depth of the shadows while preserving the integrity of the green tones.

- If you need a grayer mixture for the shadows, add a touch of Quinacridone Magenta to the green mix made with Lemon Yellow and Cobalt Blue. Don't add too much or you'll have a warm color that won't work for these shadows.

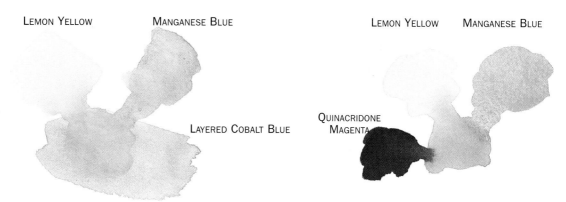

LEMON YELLOW MANGANESE BLUE

LAYERED COBALT BLUE

LEMON YELLOW MANGANESE BLUE

QUINACRIDONE MAGENTA

Step 4

Paint the magenta petals

- Now that the green petals are set we can add the punch — the brilliant Quinacridone Magenta of the inner petals. First, lay down a pale wash of Lemon Yellow on the lower right of the main petal.

- Once this has dried, apply a light wash of Quinacridone Magenta to all the magenta petals, avoiding the white edges and veins. The large magenta petal in the foreground is part of the center of interest and will therefore have more detail and sharper edges. The magenta petals in the background are not the center of interest, so they should not have any detail. Paint them with a soft edge so they will not stand out against the background when it is added later.

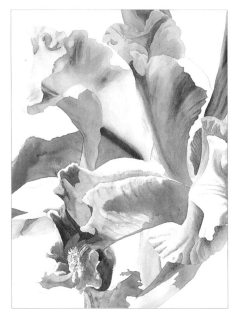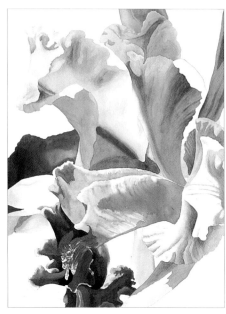

Step 5

Adjust the value

- Next, strengthen the value of the petals by applying a layer of Indigo Violet. A deep color similar to Quinacridone Magenta, Indigo Violet can be applied in light washes to enhance the vibrancy of Quinacridone Magenta or applied by itself in shadow areas.

- To further deepen the shadows, add a touch of Phthalo Green to the Indigo Violet to darken it. Again, moderation is best.

INDIGO VIOLET QUINACRIDONE MAGENTA

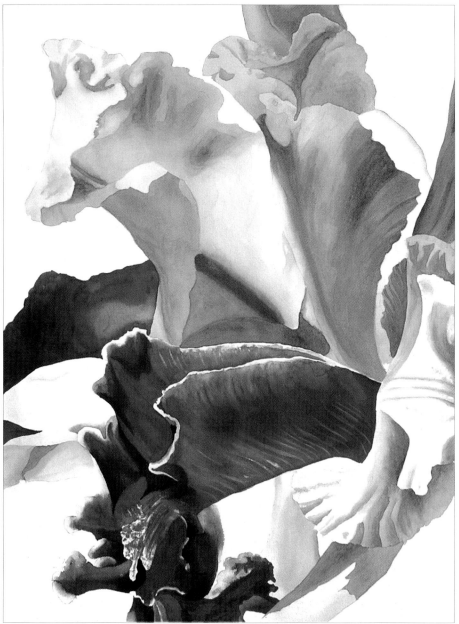

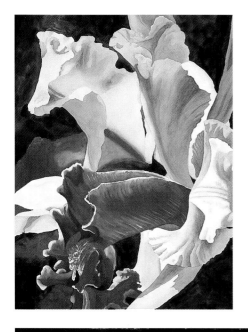
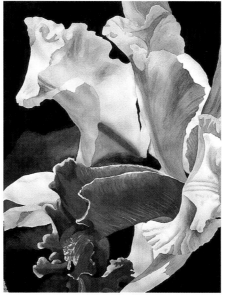

Step 6

Paint the background

● Mix a dark, almost black color with Phthalo Green and Permanent Alizarin Crimson. To vary this mixture as you're painting, add Dioxazine Violet and Phthalo Blue. Dampen the three magenta petals in the background with clear water to soften their edges so they will blend as you paint the background around them.

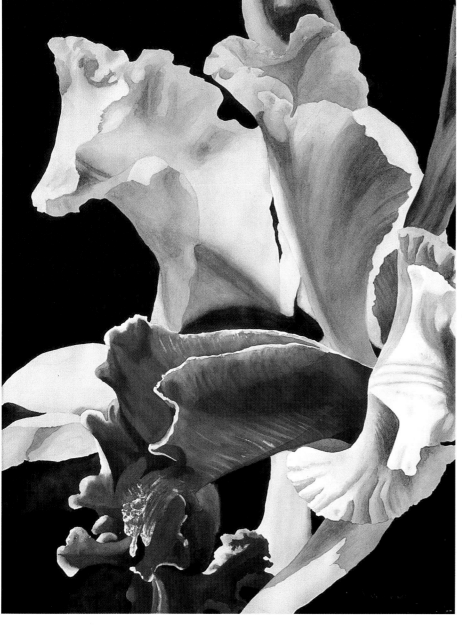

Step 7

Apply dark glazes

● Once the first background layer is dry, paint a diluted mix of Indigo Violet and Phthalo Green over the background petals to further darken them and force them to recede.

● Another coat of the almost black mix should be sufficient to create the dark background value that will really make the flower pop off the paper.

PHTHALO GREEN DIOXAZINE VIOLET

PHTHALO BLUE PERMANENT ALIZARIN CRIMSON

CHECKPOINT

In these 10 projects we have explored design, edges, color glazes, shadows, primary, warm and cool and complementary color, contrast of value and color, translucency and special subjects like white and yellow flowers.

Now you can put all this information to good use in all your florals!

LEARNING POINTS

✔ Design

Without a good design you can't create a good painting, no matter how well you have mastered the techniques. Before you put pigment to paper, take time to plan.

- Define your center of interest — the area of the painting with the most detail and the most contrast.
- Evaluate possible eye-paths to lead your viewer in and around your painting.
- Plan the values in your painting to strengthen the eye-path and center of interest.

Even when you can't wait to get painting, take a few minutes to plan. It's well worth the investment.

✔ Glazes (layers)

Layering — or glazing — is the application of additional washes of color over dry paint. Glaze when you need to

- intensify color or value
- change or create a color
- combine colors that would turn into mud if mixed on your palette

✔ Hard and soft edges

Painting flowers presents many challenges. How can you convey the lovely contours, shapes and undulations seen in the petals and leaves? Mastery of hard and soft edges is the key to painting three-dimensional flowers.

- An area of color with a very distinct and crisp edge is said to have a hard edge. Hard edges attract the eye and are often used at the center of interest and to separate the subject from the background.
- Soft edges are often called "lost." They are subtle transitions of color and can be used to represent curves and gentle shadow.

✔ Shadows

A good design incorporates dramatic shadows. Shadows lead the eye to the center of interest and provide the contrast that makes a painting interesting. When painting shadows, remember to

- establish a consistent light source
- use cooler colors when you want the shadows to recede
- include colors in your shadows

If you're painting outdoors or are using field sketches, make sure to take into account those constantly moving shadows. It's best to take backup photos to capture light and shadow patterns.

✔ Primary colors

Have you ever wanted to mix a special color, but had no idea how? Understanding how your pigments interact makes it easier to mix the colors you want. Start with just the primaries to learn what your pigments can do.

- Create a simplified palette from six colors — the warm primaries and the cool primaries.
- Learn which of your pigments are biased toward warm and cool colors.

✔ Color temperatures

Each color on the color wheel is considered either warm or cool. You can use color temperature in combination with value to give your painting depth. Watercolor pigments, however, are never pure colors from the color wheel. Learn the color bias of your pigments so you can more effectively give your two-dimensional painting a three-dimensional look.

- Warm colors — red, yellow, orange — seem to come forward in a painting
- Cool colors — blue, violet, some greens — seem to recede
- Individual pigments, themselves primarily either warm or cool, may also contain a secondary warm or cool component

✔ Complementary colors

One of the most dramatic of color schemes is the complementary color scheme. Complementary colors, when used together, have unique properties that can add interest to your painting and utility to your palette.

- Create interest and "vibration" by placing complementary colors next to each other.
- Complementary colors also brighten each other when placed side by side.
- Gray down a color by adding its complement.

✔ Value contrast

Value is the lightness or darkness of a color. Your paintings will have more depth if you use the full range of values.

- Squint at your painting to reduce it down to its basic values.
- A value scale can help you incorporate the full range of values in your painting.
- Although you don't have to use every value on a value scale, use at least a light, a medium and a dark.

I like to increase the value of flower petals by strengthening their local color. Strong color adds interest and spark to your painting.

✔ Translucence

Flowers are often at their most beautiful when bright light shines onto and through their translucent petals. To achieve this effect, you must preserve the white of your paper. Wait to tone the lightest areas of the painting until you can determine how all the values of the painting relate as a whole. Be patient and wait. If you need to tone down a white, it's best to do it later in the process than too early — you can't retrieve it once it's gone.

✔ White flowers

Painting white flowers gives you the opportunity to create intriguing, colorful shadows. Shadows are more interesting if you paint them with color instead of a gray. As long as you leave the main part of the petal white, most colors will read as shadow. Do remember to keep the colors cool to give the illusion of depth.

✔ Yellow flowers

There are so many yellow flowers that it's important to know how to manipulate this delicate color. It's the lightest color on the color wheel, so creating dark values of yellow is a challenge.

- Add deeper yellow pigments to darken pale yellows.
- Use diluted yellow for light areas, less diluted pigment for dark areas.
- Add Raw or Burnt Sienna to yellow to create a warm deep value.
- Add Manganese or Cobalt Blue to create a cool deep value.

✔ Learning from mistakes

The most important thing you need to remember is: Don't be afraid of making a mistake. Most of them are fixable. I originally painted two dewdrops in Project 4, but removed most of one when I realized it detracted from the painting. I completed Project 7 in horizontal format only to discover it looked much better as a vertical painting. Watercolor is a vibrant, flowing medium that allows us to do things we can't do with any other medium. We may never fully master it, but we can sure have a lot of fun learning all its possibilities.